THE
FASCINATION
OF
IVORY

© Godfrey Harris. All Rights Reserved. 1991

First Edition

No part of this book may be reproduced or utilized in any form or by any means, electronic or mechanical, including photocopying, recording, or by any information storage or retrieval system, without permission in writing from the author who may be contacted through:

The Americas Group
9200 Sunset Blvd., Suite 404
Los Angeles, California 90069
USA

ISBN:
0-935047-04-2
Library of Congress Catalog Card Number:
87-70049

Library of Congress Cataloging-in-Publication Data

Harris, Godfrey, 1937–
 The fascination of ivory.

 Bibliography: p. 128
 Includes index.
 1. Ivories. I. Title.
NK 5825.H37 1987 736'.62 87–70049
ISBN 0-935047-04-2

Printed in the United States of America
Delta Lithograph Co.

GRAPHIC DESIGN
John Powers and Godfrey Harris

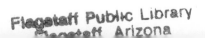
Flagstaff Public Library
Flagstaff Arizona

THE
FASCINATION
OF
IVORY

Its
Place
In
Our
World

Godfrey Harris

ALSO BY GODFREY HARRIS

Invasion (with David S. Behar)

The Ultimate Black Book

The Panamanian Perspective

Promoting International Tourism (with Kenneth M. Katz)

Commercial Translations (with Charles Sonabend)

From Trash to Treasure (with Barbara DeKovner-Mayer)

Panama's Position

The Quest for Foreign Affairs Officers (with Francis Fielder)

The History of Sandy Hook, New Jersey

Outline of Social Sciences

Outline of Western Civilization

TABLE OF CONTENTS

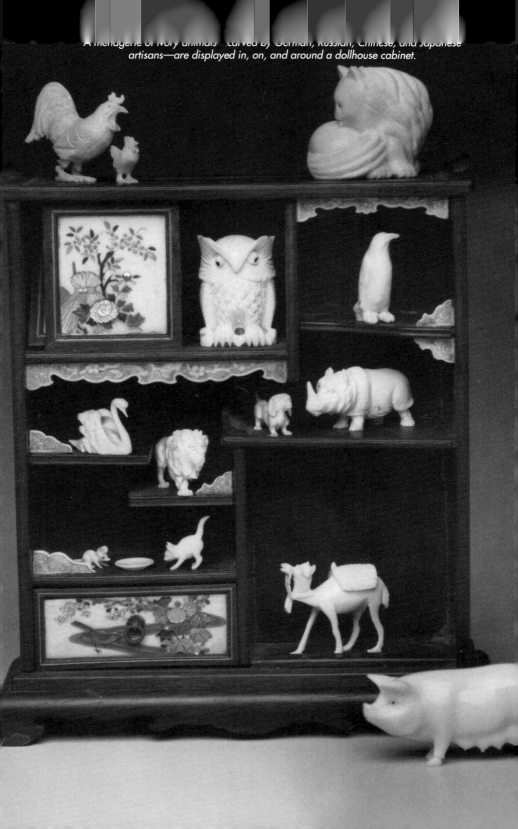

A menagerie of ivory animals—carved by German, Russian, Chinese, and Japanese artisans—are displayed in, on, and around a dollhouse cabinet.

36.4 H 3'+ t

FOREWORD

A few years ago, a close friend and I were reviewing the acquisitions each of us had made at London's famed outdoor antique market on Portobello Road. I was particularly excited by an ivory-framed, pop-up pair of reading glasses *(see photograph, p. 38),* and she was equally delighted with a three-dimensional souvenir viewer of the Great Exhibition of 1851. As my friend well knew, I had been avidly collecting objects made from or decorated with ivory for more than two decades. In the course of our discussion that day, though, I had admitted that there was still so much about the general subject of ivory that I wanted to learn.

On the airplane home to Los Angeles, I began thinking about my chance admission in the context of the number of different kinds of ivory pieces in my collection. Why, for example, had an artisan created a miniature chess table out of ivory *(see photograph, p. 101)* rather than from some other material? Why were ivory-handled straight razors difficult to find in antique markets while other male toilette articles seemed so plentiful?

Eventually a much more fundamental question about ivory as a material began formulating in my mind:

> What was there about ivory that caused its use in a wide variety of religious, decorative, and functional articles and that impelled the development of so many natural and synthetic substitutes?

After a number of visits to local book stores and libraries, I came to the realization that nearly all of the very interesting scholarly works available on ivory tended to focus on examples of its *aesthetic* uses—historically and intrinsically. Objects that were merely *decorated* with ivory—unless those decorations exhibited something noteworthy in their age, their carving, or the subject matter depicted—were hardly ever mentioned by

THE FASCINATION OF IVORY

most writers. Moreover, those ivory articles that primarily serve only a practical purpose were virtually ignored. Indeed, one writer has noted:

> *...many ivory objects, such as cobblers' measures, spindles...are of little artistic value...and a great number of absurd or even obscene little figures...are not worth our notice.*

Because of this disparaging attitude, the antique trade has even come to refer to these kinds of items as "smalls." Yet my fascination with ivory had actually begun at this level—with everyday items, such as boxes and pencils. Worse from my personal standpoint, almost all books available about ivory tend to end their discussion at the very point in history where my interest really begins—after the turn of the 19th century.

The more I looked for the answer to my basic question about why ivory in particular was used for various kinds of objects, the more I realized that I might not find it in any single published source. It was then that I started to try to formulate my own response from the ideas and observations I had begun to develop.

A journalist once observed that people write to discover what they know, and, in the process, learn more of what they don't know. This book, then, serves as a statement of what I *now* know about ivory and what I still have to learn. But if this book makes any contribution to the literature on ivory, it is that it tries to understand *why* ivory might have been employed for various objects or with various other materials. I hope this effort enlightens others. I also hope that future research and exploration of the subject will answer questions that I had had to leave open, as well as correct and refine some of the ideas that I have advanced.

I am indebted to many writers for helping me understand the subject of ivory and some of the details of my own personal collection better. Most I have never met, but the results of their thinking and research are found throughout the book and the details of their contributions are described in the Bibliographical Notes at the back. Because some of these notes are extensive, readers are urged to review the appropriate bibliographical section as they finish each chapter. To avoid interrupting the flow of the narrative, however, two types of footnotes are used: *textual footnotes*—those discussing related, but generally tangential, details of a point made in the body of the text—are indicated by a carat mark: ^; *reference footnotes*—those

identifying the *source* of a direct quotation—are found listed under the appropriate page number in the Bibliographical Notes.

Although I am solely responsible for any errors of commission or omission in the book, it could not have been completed without the help of others. Nancy Boss Art used her editorial talent to make my thoughts more understandable. L. Ara Norwood of Delta Lithograph supervised the manufacturing process. John Powers not only photographed nearly all of the ivories seen in the book, but collaborated on the book's design as well. Adrian Ionescu used his impressive computer aided design (CAD) skills in outlining the multi-object photos to make identification of individual pieces easier. Gregrey Harris, my eldest son, assisted with the early research on the book and took one of the photographs used. My middle son, Kennith Harris, supervised the computerized integration of the book from several different operating systems. My stepson, Greg J. Mayer, undertook some of the computer-related tasks involved in the book's production.

Others such as James David Draper, curator of European Sculpture and Decorative Arts at the Metropolitan Museum of Art, and George Moss, an eclectic collector and New Jersey historian, kindly offered ideas after reading a draft. My mother, Victoria Harris; my wife, Barbara (DeKovner-Mayer) Harris; my brothers David and Michael Harris; as well as my friend and collecting companion, Shirley Lister, have had the patience to read the manuscript and suggest changes they thought appropriate. Still others—William P. Butler, A. Allen Dizik, Edmund F. Lindop, Alan Lowy, Kenneth M. Katz, and my cousins in England, Philip Raphael and Donald Wand—have provided books, shared ideas, offered encouragement, or added items to my collection.

But it is to my late father, Alfred Harris, that I owe the greatest debt of gratitude. He gave me everything I would need to initiate and develop *my* fascination with the subject of ivory. For many reasons, without him, this book could not even have been contemplated.

Godfrey Harris
Los Angeles
December 1990

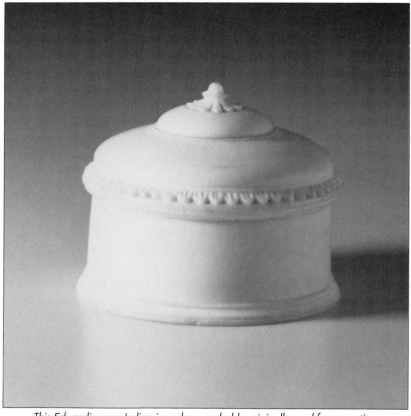

This Edwardian-era Indian ivory box, probably originally used for cosmetics or medicines, is generally referred to as a casket.

THE SPECIAL APPEAL OF IVORY

I know that my fascination with ivory began in the spring of 1948. I was 11 years old and traveling with my father on one of his periodic business trips to London—the place of my birth and the land of his roots. We were going to an England still suffering from the indignity of food rationing and the other lingering effects of World War II.

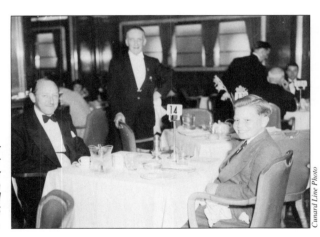

The author with his father on their way to England in 1948 aboard the RMS Queen Mary.

Cunard Line Photo

I would later come to realize that it hardly mirrored Robert Browning's famous wish:

O To be in England/Now that April's there...

But that was of little matter to my father. He was running several businesses simultaneously and most of them had their base in England. The one

enterprise he enjoyed most—but the one that yielded the least income for the time involved—was his antique silver business. So whenever he had finished looking after his scrap metal and plastic sorting plant in Richmond, Surrey—the London suburb where my middle brother and I were born—and after he had discussed his commodity trading positions in the City of London, he would be off to poke around some antique market or through some cluster of antique shops. To my great delight he would take me with him on some of his weekend forays into the countryside.

A Collection Begins

My father nearly always did his antique buying in the same way. He would approach an antique dealer's stall or enter a shop quite casually—methodically beginning a slow visual review of the goods on display. He never revealed very much interest in anything he looked at and seldom even asked for a price. If he did, he barely seemed concerned with whatever the amount quoted.

On occasion he would pick up a silver tray or serving piece and search for the maker's marks stamped somewhere on the back or hidden in some crevice. Whenever he located them, his habit would be to rub away whatever dust and tarnish there might be with the side of his thumb to try to clarify the important details of each symbol. He never seemed in a hurry.

Eventually, he would produce a pair of black, full-rimmed reading glasses from one pocket and a leather-encased, magnifying glass from another. With the eyeglasses perched on his nose, he would move the magnifier back and forth and tilt the piece from side to side to bring the marks into a better light or clearer focus. If the particular piece had two or more parts—a covered pitcher on a stand, for instance—he would also check to make sure that the marks were the same on each piece. He knew, from past experience, that some dealers were prone to mix parts from different makers and even from different eras whenever the original pieces had become separated over time. ^

^ The carat mark indicates that a comment related to an aspect of the text—in this case a few words on hallmarks—can be found under the appropriate page number in the Bibliographical Notes section beginning at page 119.

Whatever he saw, however, never seemed to evoke a comment. Whatever the proprietor of the shop or stall would say to fill in the gaps of silence was almost always received with perfunctory acceptance. It wasn't that my father was shy; he was merely waiting to hear what information the dealer might volunteer about an item or reveal about his business practices. My father would always end his review of the various bits and pieces on a stall or in a shop with a request for the proprietor to give him a single quotation on an array of goods: this tray, that soup tureen, those spoons, the two wine coolers over there, and, oh yes, all the grape shears and candle snuffers that might be in stock.

The reaction nearly always seemed the same—surprised silence. My father once explained the reasons:

- The smaller dealers were generally dazzled by the sheer size of the potential sale.

- They were hard put to assimilate the fact that he had studied only a few pieces, but now asked for a quotation on a blizzard of items.

- They never seemed to be able to remember all of the pieces that my father had specified.

While they fumbled to take notes, to assemble the items requested in one location, or to check their stock books for the prices *they* had paid, my father always added that he assumed he would be given their absolute best trade price at the outset.

Once that price would be announced, my father seemed to do an unusual thing: rather than question the amount, he would begin adding and subtracting pieces from the package. When a new total price was reached, he would sometimes continue substituting various items into the package of goods he seemed bent on acquiring. The bargaining over the final configuration of goods to be sold and the total amount of money to be paid was never prolonged.

Whenever a deal was finally struck, a long narrow check book would emerge from another of my father's pockets along with a business card for preparation of the invoice. He would then give instructions for delivery of the goods to a freight forwarder and after a few pleasant words and a bright "cheerio," we would be off to the next stall or shop.

Before long, I began to emulate my father's practice. As he would start going through his ritual, I would be looking at items that drew my eye. The pieces that attracted me were always small, always involved something that opened or closed, and usually were made from some exotic material. Occasionally, I would ask if I might keep a piece that fascinated me. Without ever protesting or even allowing me to spend my own money, my father would simply add the item to the package of goods then being discussed.

I still have the very first piece I asked to keep on that trip. It is the basis of my ivory collection—a little round ivory casket. *(See the photograph, p. 10.)* It was probably made in India at the turn of the century to hold some cosmetic or medical item—or even a gift.^ The lid of this particular casket screws onto its base. The ivory threads are chipped today, just as I found them on that day in June 1948, when a price of 5 shillings (about $1 at the time) was added to whatever else my father purchased at that particular shop.

I asked for other things as we made our way through the south of England that summer. As it turns out, these other items were either made from or with ivory or closely linked to the general subject of ivory. All but one of the non-ivory pieces, however, were eventually sold in my father's antique shop.

An Antique Shop in Los Angeles

That shop—called the Harris English Silver Company—really had two halves. The front was elegantly carpeted and beautifully lighted for the public. It was a showroom for the old silver pieces displayed on Victorian dining room tables, in breakfronts, and on library stairs and book shelves. The back half of the shop was private and much more Spartan. It contained my father's desk and bookcase, a couch for visitors, and his secretary/bookkeeper's large work table. A partition separated the office area from a spacious shipping and storage area.

As a merchant who had been buying and selling anything of promise that came his way since he was 14 years old, my father had an amazing capacity to wear several business hats at the same time. One moment, he could be on the phone getting aggravated over the management of his real estate holdings or tapping out a buy/sell order for a pepper contract on an enormous Teletype machine. In the next moment, he would be in front of the shop

smoothly discussing the artistic merits of some silver basket or suggesting how a Victorian epergne might be converted into a table lamp.

His success at business was a continuing willingness to take risks—and a sense of humor that enabled him to accept his losing gambles with a shrug and to enjoy his winning ones with a wry smile. His humor also allowed him to stretch the truth, if necessary, in the interest of closing any worthwhile sale.

Photographer unknown

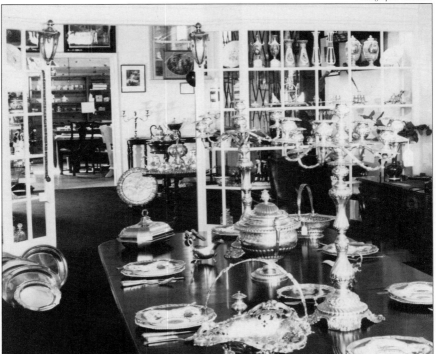

The Harris English Silver Company in Los Angeles in the late 1940s.

The Harris English Silver Company, for example, proclaimed its establishment in 1898. Not that the business itself was actually that old—it was really the year of my father's birth—but he said it gave customers in the fast-growing Los Angeles area a feeling of old world strength and reliability. Items of potential historical importance could emerge in his conversations with prospective buyers as "possibly" connected to some aristocrat's manor house or having features which might be "attributable" to the school of some famous artistic name. He seemed to take great delight in his ability to

conceive of these linkages—the more elaborate he could weave them, the more fun he would have.

One summer in the 1950s, I was again working in the shop. I used to do a bit of typing and run errands for him. My main task, however, was to polish the silver. One day, a New York dealer had an appointment to see a particular silver wine pitcher of undisputed age, but unknown history. I was told to clean the item for its inevitable inspection.

My father was well into one of his more involved routines about the possible genealogy of this particular piece when he picked it up. He was obviously pleased to see that I had done my job properly and that the weight of the pitcher would tend to reflect its value and authenticity. He then handed the pitcher to the dealer who promptly turned it upside down to confirm my father's description of the silver marks on the bottom. As he did so, a cascade of dirty water—the remnants of my cleaning effort—went all over the front of the dealer's suit. My father mumbled something about the wretched risks of the antique trade these days and shot me a look that would have altered the path of a charging elephant. The New Yorker, having lost all semblance of concentration as he surveyed the muck and goo starting to congeal on his tie and jacket, said he would return once he had changed his clothes. He never came back.

Rather than banishing me from his sight for the summer—as I had expected—my father started one of his litanies to the heavens that went something like:

If you want anything done, do it your bloody self...

As he played the scene back in his mind, though, it seemed to calm him down. He obviously began to see the Chaplinesque humor of the moment. Instead of sentencing me to some long-term punishment, he decided to give me more training in caring for antiques.

As he took me back to the workroom, he proceeded to explain that thoroughly drying and polishing a piece not only prevented the kind of disaster we had both just witnessed, but served to reveal any flaws, cracks, or damage to an item that might otherwise go unnoticed or unrepaired. To this day, the first thing I do with any ivory piece acquired for my collection is to wash it gently with a little soap and warm water, then dry it carefully with a clean towel.^ It is still a revelation to me to realize that no matter how

long I have studied an item in a shop before buying it, I learn so much more about the intricate details of a piece in the process of cleaning and drying it.

Acquiring Ivories

But in England that summer in 1948, I was only at the outset of my understanding of antiques. After a few weekends on the road, I had the feeling that my father was starting to treat me as a sort of apprentice buyer, rather than as a child who had to be placated from time to time.

Of course, he was not really interested in what I was selecting. He just wanted something else that could be thrown into the stew of items he was trying to acquire at that moment from some dealer. His target, I would find out many years later, was usually only one or two pieces in the package he kept putting together, taking apart, and reassembling. He, of course, never indicated to the proprietor what the piece might be.

But he realized that most antique dealers could not resist making a substantial sale involving an amount considerably larger than the average buyer would likely spend in any given transaction. As long as the total was great enough, my father knew that either the target item itself or the other pieces in the package might be acquired at a bargain price.

A Harris English Silver Company antique show stand in the mid-1950s. Note the five ivory portraits on display on the table at the far left.

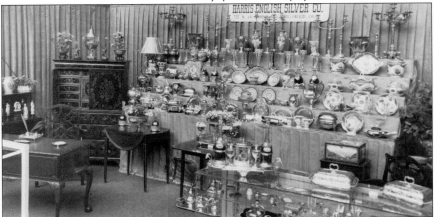

Sam Little Commercial Photography

Dealers, he would later explain to me, generally only reacted to the *total* amount of a transaction. Subconsciously, they began to envision what they might be able to do with a large amount of cash—make an investment, pay off a debt, or acquire a major piece coming to auction. In England in 1948, when times were still very difficult, a lump sum payment could be quite appealing. As a result, some dealers tended to pay less attention to the value of individual pieces involved in a single sale.

My father also intuitively realized that antique dealers love to find and buy goods much more than they like to sell them. As a result, one large transaction could give them the chance to buy many other things in the ensuing months, while in fact selling him what he wanted. Since we seemed to visit a number of dealers that were familiar to him, I now suspect that some of these people served as his uncommissioned agents. They did the searching, bargaining, and buying they so thoroughly enjoyed; he, in turn, got to see the goods he might want for sale in his store in Los Angeles and at antique shows across America.^

Over the years, my father never made much money at this trade because eventually he tended to treat the business as an extension of his own personal antique collection. The really valuable and often most expensive items that he acquired went home. Of course, if anyone asked for something he had already presented to my mother for placement in our house, he might be inclined to take it back to the store. I remember one piece in particular:

> It was the very large hoof of a Clydesdale horse—outfitted as an ink stand with silver and tortoise shell mountings. It was one of those items I had asked for on that trip to England in 1948. Unfortunately, it didn't last long on the little desk in my room. It soon went back to the store to be sold to a decorator arranging some movie producer's new office.

The only items that I can remember always going home—and only returning to the shop or a show for display—were my father's major ivory pieces. He bought small statuettes (called *portraits*), plaques, and finely carved fragments whenever he saw them on his trips. They invariably went into a cabinet or onto a table in the living room where he could enjoy them.

Eventually, when my father was well advanced in years and I had returned to Los Angeles after several diplomatic tours abroad, he asked me to arrange to give most of his collection to the New York Metropolitan Museum of Art.

He thought the pieces should be available to be enjoyed by others and he refused to live in a house wired with an alarm system like a bank vault. It was either that, or pay more to insure the collection each year than the items had originally cost him. Some of the pieces from his collection can be seen today

Photo by the Metropolitan Museum of Art

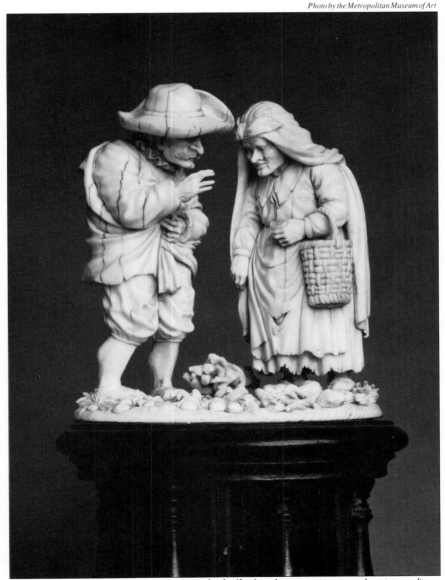

"The Old Peasant Couple" was a 1976 gift of Alfred and Victoria Harris to the Metropolitan Museum of Art. The carving is described by the Museum's experts as "German, probably XIX century in imitation of XVIII century model."

on permanent display at the Met.

All of this has relevance. My father's collection of antique furniture, silver, china, and ivory objects reflected his interests, his tastes, and his pocket-book. When I began my own collecting in earnest, I found myself still attracted to the same kinds of items that first caught my attention that summer in England. I only seemed to have eyes for pieces made from or embellished with ivory—and particularly those pieces with unusual designs or uses. Today I have upwards of 600 individual items made from or decorated with ivory.

Only a few of these pieces, viewed by themselves, could be considered museum quality. As a whole, though, the collection has some merit in bringing various samples of ivory and ivory workmanship together. And nearly all of the pieces can evoke a conversation about what they might have been used for or how they might have come to be sold.

One of the items I acquired a few years ago is a case in point. It is an **ivory-handled trowel.**^ On the face of the wedge-shaped, silver blade is an inscription:

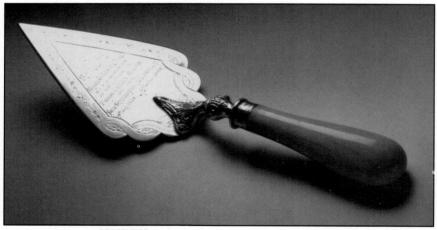

PRESENTED
TO
HYAM GOLDBERG, ESQ,
ON THE OCCASION
OF HIS LAYING THE
FOUNDATION STONE
OF THE
NEW SYNAGOGUE, LLANELLEY,

14th July, 1908 15th Tammuz, 5668

I have always been fascinated by this handsome piece. I want to believe it was the source of considerable pride and satisfaction to Mr. Goldberg for the contribution he must have made to the Jewish community in that small industrial town on the southern coast of Wales. Yet, how did it come to be on sale at a small stall in an outdoor antique market in London in 1964?

Did hard times force the family to sell their treasures and heirlooms accumulated over decades? Were this man's heirs piqued to have to look at a constant reminder of how he had spent a part of what they might have expected as their inheritance? Was this ceremonial trowel just one of many such mementoes received by Mr. Goldberg over the years—and the least interesting one at that?

I will probably never learn why this piece came on the market, just as I will probably never know the entire the story behind most of the other items in my collection. But I believe part of the fun of collecting anything is not only assembling a group of related items, but in learning as much as possible about the places, eras, and people involved *with* the various pieces.

I think my interest in all things ivory was inspired by the same elements that seemed to fascinate my father:

- The warm soft look of the material itself with its distinctive grain and inner glow.

- The infinite smoothness of the material, as well as the perfect detail of expression, shading, and proportion that can be carved in ivory.

- The frequent miniaturization of all ivory objects that permits them to be easily seen, handled, and studied in all three dimensions at once.

- The skill and experience needed to determine authentic ivory pieces from items made with other materials.

But since I knew I couldn't afford the same kind of ivory sculptures my father had assembled, I at first became attracted to tiny ivory representations of animals. I kept these little creatures—carved in exquisite detail and into realistic stances—on the shelves of a Burmese dollhouse cabinet. *(See photograph, p. 6.)* After a while, the menagerie outgrew its display area.

Then on a trip to Panama in 1967, I was drawn to a modern ivory **cribbage board**—the key ingredient of a game I had come to adore. This discovery set the stage for my interest in trying to acquire other types of *practical* ivory objects.

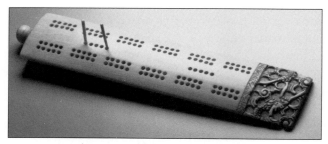

Modern ivory cribbage board from India.

Since that trip, the central theme of the collection has evolved to the different ways ivory has been employed to portray or enrich objects with a religious, artistic, or functional purpose. My search for unusual examples of the uses of ivory continues, constrained only by my pocketbook.

Just a few years ago, for example, I saw a pair of ivory sandals for the first time—perhaps the palace slippers of some oriental princess. Before spotting them at a market stall, I hadn't even known that ivory had been used to make entire pairs of shoes. Each of the 1/4 inch (about 6.3 mm) thick ivory soles was cut in the shape of a foot. The heel wedges were slightly scuffed from use, and the knob—the gripping point for the toes—was delicately carved in the shape of a flower.

The asking price for these sandals, because of their rarity as well as their outstanding condition, was high. I was forced to leave them behind for some other collector or museum curator. Although I felt sad having to pass on something of such unusual interest and quality, I learned something from considering them and I have never forgotten them. But I reasoned that the amount of money involved could be better spent filling my collection with dozens of other fascinating objects that I knew were still available and waiting to be acquired.

Trying to find and categorize all the uses to which ivory has been put has proven to be only one aspect of my personal collection.^ As noted before, I have also been trying to understand why ivory was used by people for various products they manufactured. Sharing my learning, my observations, and my ideas about ivory and its uses is one of the reasons I decided to write this book.

UNDERSTANDING IVORY

Throughout history, ivory has been used to satisfy a broad range of man's needs and interests:^

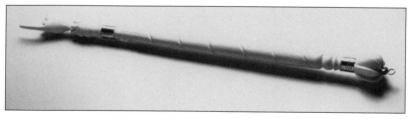

It has been carved into various forms for *aesthetic admiration* and *religious devotion*—as in this 19th century Russian *yad* (a pointer used in reading the Torah).

It has been used for all kinds of decoration and *personal adornment*—as in this modern ladies' **ring**.

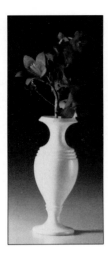

It has been shaped into a variety of objects of *utilitarian value*—as in this beautifully turned ivory bud **vase**.

And it has been used to visually enrich countless items of a *practical* nature—as in the handle mounts of this pair of 19th century fold-up, cross-cut **scissors**.

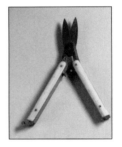

A Precious Material

Ivory, it seems, has long been in the pantheon of precious materials sought by artists and craftsmen the world over. It is mentioned in the Bible and found among the artifacts of the oldest known civilizations. Like gold, silver, diamonds, and a few other substances, ivory has been coveted for its innate beauty, scarce supply, and special properties.^ As such, it has been etched into illustrations, carved into jewelry, shaped into decorative designs, and sculpted into statuettes.

Flagstaff Public Library

And like most other precious materials, ivory has also been used for a number of practical and decidedly mundane purposes:

- The ball used in lawn bowling is called a **wood**. Each wood has a little plate imbedded in its side to identify it from the woods of other players. In the past, these little round or oval plates were made from ivory or bone and were etched with the initials, crest, or personal symbol of the wood's owner. No one seems to know why ivory or bone, more so than gold or silver, was used for these identifying plaques.

The best guess is tradition. Someone probably originally used this material simply because the color contrast to the darker tones of the wood was pleasing to the eye. Other craftsmen merely followed suit when making the same product for their clients. A second guess suggests that the feel of individual woods would not be affected by a relatively lightweight ivory panel, but might have altered if a heavier material—such as gold and silver—were used.^

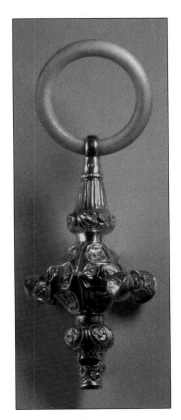

• **Infant teething rings** and feeding spoons made of ivory seem to have been favored by mothers in Victorian times. They knew that ivory was particularly resilient, yet splinter resistant, and would absorb heat from food rather than conduct it into a baby's mouth.

• When sliced into thin wafers, ivory can become a useful surface on 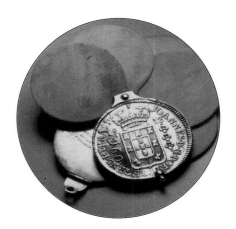 which to write. Lead pencil markings can be as readily erased from ivory as chalk can be removed from more cumbersome slate. As a result, a few such wafers, when joined together, formed a lightweight, portable, and continuously reusable **notebook** for gentlemen to tuck into a pocket or women to carry in their handbags.

But unlike all other precious materials, save jade, ivory lacks a standard definition.^ While any elementary chemistry textbook contains a precise and unvarying description of gold or silver ore, no such universal definition of what actually constitutes ivory exists. Perhaps the fascination of ivory has to begin with the rather surprising fact that:

> Something could maintain its special appeal and high value through thousands of years and across dozens of different civilizations even though it actually consists of several distinctly different materials often used interchangeably.

Defining Ivory

Today, ivory is generally only thought of as the material found in the tusks of elephants. Yet not all elephants have tusks. The female Asian elephant, for instance, is unable to grow them, and some African elephants—male or female—are unable to produce them. But ivory is also found in tusks grown by several other animal species—boars, walruses, and narwhals, for example. The ivory in the tusks of these other animals, though, is slightly different in look and texture from the ivory produced by elephants. Even the tusks of prehistoric animals, such as mammoths and mastodons—ivory material of high value that is still being recovered by archaeologists—look different from elephant tusks.

The one common thread in all tusk ivory is that it is made of a *dentine* material. As such, a tusk is actually an enormous tooth growing outside of the animal's mouth. Some interior teeth are also considered ivory and are often carved as such. They include the teeth of the hippopotamus, the sperm whale, and the warthog. The tusk of an elephant is specifically the animal's upper *incisors*—the teeth usually associated with the cutting of food. Walrus tusks, on the other hand, are the animals' upper *canine* teeth—the teeth used principally to hold things.

All types of tusks are distinguished by the fact that they continue to grow throughout the life of the animal. Some monumental elephant tusks have measured more than eight feet (2.4 m) in length and weighed more than 200 pounds (91 kg) each. Elephants also tend to favor either their left or right tusk, much as humans are either right or left handed. The favored elephant tusk tends to do more work and usually ends up shorter and more damaged than the less used one.

Even though a **tusk** is actually a tooth, tusks lack the kind of enamel coating found on the interior teeth of, say, a whale. Enamel on an elephant tusk appears only at its very tip where the tusk receives the most abuse. Because the enamel is so hard, it tends to discourage carving and shaping of the tip. It is for this reason that the technique of *scrimshaw* is associated with an etching scratched into the enameled surface of a whale's tooth, rather than a three dimensional carving common to most tusk ivory.

An animal's dentine material, moreover, is quite different in composition from that same animal's protective horns or its skeletal bones. It also looks different when cut into sections or after it has been polished. Yet bone, some antler, and a few specimens of horn have all in the past been labeled by trad-

ers, artisans, collectors, and commentators as "ivory"—without any further qualification as to the *actual* origin of the material itself.

It appears, in fact, that in the period before the colonization of sub-Sahara Africa by European nations, very little distinction was made among the varieties of "ivory" material then in use. European artisans of the day used whatever natural, whitish substance might be both suitable for the object being crafted and reasonably available. Given the current ban on trade in elephant tusks and the search for a suitable natural substitute, we may again return to a period where artistic creativity, rather than the material itself, becomes the focus of the public's attention.

It was only after the early exploration and colonization of black Africa— starting around the mid-1500s—that a reasonable number of elephant tusks consistently began making their way to European centers of artistic activity. It was then that the qualitative differences between elephant ivory and all other forms of similar material began at least to be recognized, even if they weren't always accurately labeled as such. But how did ivory come to achieve this special place of value? It seems probable that from earliest times man recognized that ivory tended to *survive* after so many other substances had either disintegrated or faded into obscurity. As such, ivory came to serve as a principal means of recording facts, legends, and ideas for future generations in a way that other material could not.

Ivory's Special Qualities

Besides its longevity, elephant ivory also seemed to be more appealing to craftsmen and their clientele than bone, horn, antler, or even the beaks of birds. All of these other substances are a form of cuticular material—the hardened surface of the skin that also creates a reptile's scales, a tortoise's shell, as well as the hoofs, claws, and nails of all mammals, including man. ^

It is not hard to understand why ivory proved to be so appealing:

- Elephant ivory was intrinsically more *attractive* because of its creamy white natural color. It tended to remain both softer in tone than the bleached white look of bone (perhaps frighteningly associated with death) and more lustrous in appearance than the shiny surfaces of antler. While elephant ivory's uniform grain was usually visible, it was more subdued and continuous in pattern than the short black marks, tiny knots, and numerous imperfections common to other materials then referred to as ivory.

- Elephant ivory was more *pliable* than bone, horn, or antler and thus easier to work into specific shapes. This pliability enabled artisans to peel strips of ivory from a single tusk to create a veneer to use with larger, more intricate, or more complex forms.

- Even without peeling off strips, ivory generally yielded vastly *larger* segments of material to work with than any single bone, piece of horn, point of an antler, clump of coral, or solitary tooth. That, too, greatly expanded the artistic options of how to employ ivory.

- Ivory was simply *scarcer* than bone, horn, beaks, antler, or teeth because of the source from which it came. This factor, plus the great distances elephant ivory had to be transported before it could be used, added to its value and attraction.

As a result, when ordering objects to be made for use in their homes or for their own personal adornment, wealthier consumers began to specify that *elephant* ivory, not other materials simply referred to as ivory, be employed.

While the word ivory is still used by some as a generic description for *any* natural material that has a particular creamy white color and a distinctive grain, most people think of ivory in only one way—as the product of an *elephant's tusk*. Bone, horn, and other substitutes now tend to be identified and known by their specific names. The difference in these various materials, of course, is much like the difference we recognize in cars. While all cars are referred to as automobiles, a distinction is made between a Rover and a Rolls Royce. They are not treated by the marketplace as equal in anything other than their capacity to transport things from one place to another.

So, too, with ivory. Elephant ivory is clearly the preferred material among all substances generically referred to as ivory. It probably always was. In fact, the very term elephant ivory turns out to be an etymological redundancy. Our word *ivory* comes from the old French word *ivurie* which, in turn, probably emerged from the Latin word, *eboreus*, meaning "elephant ivory."

Bone

Of all the natural materials that have been used as a substitute for ivory, bone is clearly the most widely used. Some very old and beautiful pieces have been made from bone. Most observers would also accept the point that bone

work found on the consular diptyches and in the prisoner-of-war miniatures is equal to anything accomplished during the same eras in ivory:

- The famous Gothic-period consular diptyches—the beautiful and intricate covers used to encase the clay and wax tablets on which messages from one government official to another were written—were nearly all crafted from bone material. In fact, diptyches were so common a means of sending a dispatch that only those intended for close friends in exalted positions appear to have been carved from elephant ivory. Later, the concept of two hinged ivory panels was expanded to three and more panels joined together. These are referred to as triptyches and polytyches. The bone panels of these other forms, rather than serve in the capacity of an envelope, were used to enclose a statue or other religious symbol.

- French and American prisoners of war, held in England as a result of the War of 1812 and the Napoleonic Wars, created the most delicate and fascinating miniatures imaginable from the bones of animals. These carvings were sold by the prisoners to upper middle class and aristocratic English families. Given the intricate and charming work the prisoners produced, it is probable that some of them were experienced ivory craftsmen. Others, no doubt, had merely been exposed to the work of ivory carvers while living in the French seacoast town of Dieppe or while serving on American whaling vessels where scrimshaw was actively practiced. They either continued their craft or emulated it while in captivity—even though only sheep bones from the kitchens were generally available to them. Their carvings helped to keep them busy and earned them a little spending money to improve their living conditions. Exquisitely detailed sailing vessels, children's toys, dollhouse furnishings (such as the **chair** above), and other common objects are today highly prized by some collectors. ^

Throughout history, bone has probably been used for more practical and decorative applications than ivory—no doubt, because it was in much more plentiful supply and was far less expensive. Several items, howver, come to mind for which only *bone*, rather than ivory, would do:

- Bones made natural and useful runners for sleds and blades for skates. Rib bones, particularly, have the appropriate shape and strength to assist the populations of colder climates in crossing frozen bodies of water and fields covered with snow.

- The rib bones of whales became the support mechanism for the corsets required by Victorian fashions. These bones had the requisite length and strength to compress a woman's flesh from bosom to belly to create as small a waist as possible. Some of these rib bones were fashioned by 19th century Danes into **ladle handles.**

More recently, a new form of bone has been created as a substitute for ivory. The Chinese have taken to pulverizing different kinds of fish bones into a fine powder, mixing the powder with a resin substance, and compressing the resultant material into blocks. Once these blocks are hardened and dried, they are suitable for carving and polishing into an

assortment of decorative objects normally associated with ivory craftsmanship. The supply of this new material and its potential size are virtually limitless. Some dealers have also taken to dipping this reconstituted material into tea to give it or the resulting objects the color and outward patina of older elephant tusk ivory.

I once unknowingly bought one of these reconstituted bone objects at an antique store just outside the precincts of the Flea Market in Paris. The object appeared to me to be an impressively etched, large-sized scrimshaw tooth. Even though I knew very little about scrimshaw at the time, the dark color and abnormal weight of the tooth troubled me.

After considerable dithering, though, I finally decided I would buy it. As I told my wife who had patiently watched me study this item, I was either acquiring one of the best bargains, or one of the most expensive fakes, of my collecting career.

The scene on one side of this tooth showed a portion of a Caribbean port with the name of an English trading company barely visible on the etched sign post of a building. After I returned to England, an associate helped me to discover that the trading company was still in business. A discussion with, and subsequent research by, the company's archivist determined that the firm had never had a permanent operation in the Caribbean and would have been unknown to sailors from that region.

Pleased with my detective work, but unhappy that I probably had *not* acquired a bargain, I was later stunned to see dozens of exact duplicates on display at a London outdoor market. These duplicates were all priced at a fraction of what I had paid in Paris. The English dealer explained that he had obtained these particular "scrimshaws" from an importer who was bringing them in from China.

He said he would be happy to arrange for me to acquire hundreds more of them with the same or different scenes for the American market. I passed. The irony of this story is that I later sold the piece at a swap meet for *more* than I had paid for it. The buyer barely seemed to listen to my explanation of its probable origins before tucking the piece tightly into a carryall and rushing away to be lost in the crowd. I am convinced that the buyer thought she was getting the biggest bargain of *her* life in the "scrimshaw" tooth I was selling. ^

Although the workmanship of these pulverized bone objects is often impressive, they can never rise above their origins to become something they are not. That is, they ought to be thought of in the same way as rhinestones. Rhinestones can be beautiful and they can be enjoyed for what they are. They should not, however, be sold or priced as diamonds.

Ivory-Like Materials

Understanding ivory doesn't end with the difference between new and old forms of tusk ivory or natural and reconstituted types of bone. With the creation of plastic materials, a blizzard of imitation ivory material began to appear. ^

The first synthetic plastics, in fact, were created specifically in the hope that they would become a worthy substitute for genuine elephant ivory. They not only proved to be just that, but early plastics such as celluloid were soon adopted for much wider uses as well. Thomas Alva Edison, for one, considered celluloid a better material for his new phonograph records than wax and he later used celluloid for the film required to show the first motion pictures.

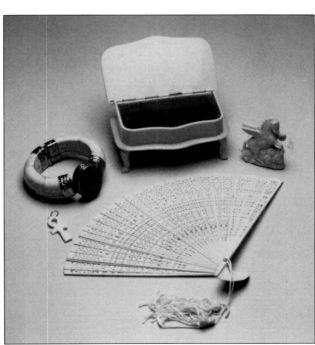

Material often substituted or mistaken for ivory include (clockwise from the top): A French ivory plastic box once owned by entertainer Liberace; a stone Pegasus paperweight; a reconstituted fish bone fan; a water buffalo bone Coptic cross; and an alabaster bracelet.

After celluloid's first appearance in 1868, other wholly synthetic plastics were brought to market. Each, in turn, was developed to become a more acceptable substitute for ivory than celluloid. As a result, these other plastics appeared with a wondrous collection of trade and popular names such as: Ivorine, Eburine, Bakelite, Fiberlite, faux ivory, French ivory, Ivoire Parisienne, vegetable ivory, and celluloid ivory.

Some plastic objects have been shaped, colored, and cracked to look like real ivory; some are spectacularly accurate reproductions of carving styles associated with particular pieces or eras.

My favorite **umbrella** always evokes comments on its impressively carved handle. While it looks very much like ivory, it is actually a polymer substance. Even close inspection of the handle fools some people. It fooled me when I hurriedly bought it at a market a few years ago. I am very fond of it, though, not only because it is handsome in itself, but because it serves as a constant reminder that good fakes abound and that even people who claim a degree of expertise in identifying ivories can make mistakes when determining the authenticity of any particular piece.

Celluloid, Bakelite, and Fiberlite, with their characteristic light grain stripes, all have a strong superficial resemblance to real ivory. Only the general uniformity of their overall color and the perfectly parallel pattern of the grain markings suggest that they are not. Nevertheless, many pieces made with this material are now approaching an age of 100 or so years. As such, they have become legitimate antiques in their own right, are emminently collectible, and are beginning to command prices that reflect their age, their special history, and their own intrinsic value.

It should also be noted that some objects that look like ivory are not tusk ivory, bone, horn, antler or even plastic imitations of ivory. They are simply products made of a totally different material, that from a distance or under certain lighting conditions can give the appearance of ivory. Sandlewood, for example, has an ivory-like color and is often carved into objects similar to those made out of ivory. On close inspection, though, sandlewood neither feels like ivory nor looks like it. For one thing, wood lacks ivory's glow and its grain tends to move in tightly circular, rather than basically longitudinal, patterns. Piece for piece, sandlewood is also much lighter in weight than ivory.

The ivory nut comes from a particular species of South American palm tree. When the nuts are exposed to air, the creamy white substance surrounding them hardens and takes on the appearance of ivory. This substance was for many years one of the favorite materials for making buttons. In fact, it proved so acceptable that genuine ivory buttons are hard to find—except those that were made as studs for formal evening shirts. (*See photograph, p. 45.*)

Some ceramics, stones, and even porcelains also produce the same outward appearance as ivory. Meerschaum clay—used mainly in making tobacco pipes—can often look just like ivory. So can alabaster. But on inspection, ceramics, stones, and porcelains prove to reflect much more light than ivory and are either too smooth or cold to the touch to be ivory.

Mother-of-pearl, other shell products, and some fish scales have been used for furniture decoration and jewelry—for both inlay and overlay patterns—in much the same way that ivory has been used. So have the beaks of birds. In fact, one species of woodpecker is called "ivory billed" because of the color, size, and hardness of its beak. Like sandlewood and ceramics, though, aquatic and avian materials are clearly not elephant or walrus ivory when subjected to close inspection.

Differentiating Other Substances from Ivory

It should be noted here that age in ivory objects is a matter of the *date when the carving was done*, rather than the age of the material itself. Some new pieces available on the market today have been carved from some very old forms of ivory. Not only mammoth and walrus tusks, but raw elephant ivory

—with their original custom's markings dating from Victorian times—may still be readily purchased. Modern day artisans can acquire this material and imitate old carving styles and forms of ivory objects in their work. Many do. In fact, examples of new ivory pieces and styles are relatively hard to find. While imitative ivory works may not be fakes *per se*—that is, not in the same sense that a copy of an oil painting, sold as an original, is a forgery—they should still be identified as new pieces crafted out of older ivory and priced accordingly.

The purpose of knowing the difference among all of these materials is much more a question of economics than aesthetics. Item for item, tusk ivory objects tend to be more expensive than items made from or with bone, horn, antler,coral, plastic, or other ivory-like materials. Yet many of these latter objects can be visually more appealing than many pieces made out of elephant ivory. When it comes to differentiating between tusk ivory and bone, not all buyers *know* the difference, and not all dealers can *tell* the difference. For some people, of course, the distinction is unimportant; it is the object itself and/or the subject matter of the work that is of most concern.

A number of years ago, my father had a friend who bought and sold fine antique objects in New York. His son was about to enter the business after attending an Ivy League university. The father decided to send his son to a real world graduate school abroad. He provided the fellow with something like $25,000—a considerable sum in those days—and the authority to acquire whatever small objects he thought might sell in the shop. After the young man had returned from his summer in Europe, my father asked his friend how the son

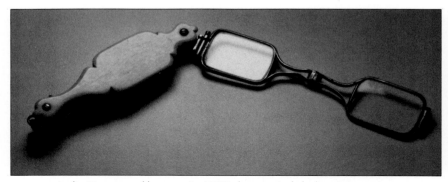

Ladies' ivory-cased lorgnette (c. 1900) shows typical elephant ivory grain.

had done. I have never forgotten the reply as it was relayed to me: "At least the fakes he bought were all in good taste."^

The same principle should be applied to ivory objects. Whenever an object is acquired, it ought to hold some intrinsic appeal to the buyer. Whatever material has been employed in its manufacture, it ought to enhance the object's appearance or utility. And whatever the price eventually paid for the object, it ought to reflect both its attraction and its substance.

Identifying Genuine Ivory

There are some rules of thumb—and some useful tests—to aid in determining what is authentic ivory, but a written explanation will not suffice to make an expert out of a reader. No one test is sufficient, and few absolutes can be stated about ivory. Here, though, are some ways I use to try to tell elephant and walrus ivory from all other forms of natural or man-made material that have the appearance of ivory:

- The *grain* one must see in ivory is its most distinguishing feature. The grain of elephant ivory, cut longitudinally from base to tip, is a series of long wavy lines that appear along the length of any smooth surface of the piece. The lines tend to travel closely together, but they can also be widely separated. They almost never appear perfectly parallel or uniform in the undulations of the wave pattern. When ivory is cut down *through* the center of a tusk, a pattern of checkered or reticulated boxes is formed by the grain lines. These figures are again distinguished by their random size and the differences in the various angles the corners of each box make. Walrus ivory, on the other hand, has a mottled appearance, with a large dark center core surrounded by a thin white outer rim.

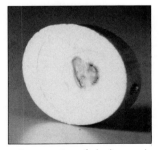

Cross section of elephant tusk showing both characteristic grain pattern and central nerve.

 The most important point when dealing with ivory grain is to be wary of uniformity. Uniformity is always a good signal that the material may be man-made.

- The smooth *texture* that elephant ivory is famous for is sometimes the most difficult aspect to test. Texture is often masked by the subject matter or the carving style of the piece under inspection. Cutting and etching ivory often robs the material of a totally smooth surface sufficiently large enough to use for feel.

 My own test of texture is to rub my thumb lightly and deliberately over any smooth, polished surface I can find, no matter how small. If I feel a very slight resistance to the movement of my thumb, an almost imperceptible amount of friction, I start to believe I have ivory in my hands. If, however, my thumb seems to glide over the surface too easily—the material offers no resistance whatsoever or feels too smooth, slippery, or silky to the touch—I usually suspect a form of plastic. If, on the other hand, the surface is uneven—it feels brittle, nicked, or very dry—I suspect bone. If it is sticky, I tend to think it may be horn. If it is cold, I suspect some kind of ceramic or stone.

- *Color* is the least reliable of all aspects on which to judge the authenticity of ivory. Ivory, even in its natural state, has hundreds of hues and shades. A creamy white color is generally where ivory starts. Some observers believe that pieces that come from the center of the tusk are whiter in appearance than those cut from nearer to the outer walls of the tusk. Some commentators state that Western African ivory is both harder and darker in color than other varieties. While I have been unable to confirm these beliefs for myself, we do know that exposure to the sun or to the heat of a fire tends to yellow ivory. Constant exposure over the years can turn the yellow into a light brown color. If the entire piece has a fairly *uniform* tan or brownish color, it is likely not to have reached that point naturally. Ivory dipped in tea or other vegetable dyes can be "aged" in minutes. ^

 Spots of deeper coloring usually reflect the fact that a piece has remained exposed to the same light source over a long period of time. Ivory tends to absorb light gently providing that inner glow that gives ivory its special appearance. Ivory is not glossy and does not reflect light brightly. When a surface tends to act like a reflector, it is likely to be plastic; when it takes on a varnished look—with shining high points—it is likely to be horn.

- *Cracks* are endemic to most older ivory. They appear when ivory has been subjected to sudden changes in temperature or to the effects of prolonged drying. In Victorian times, for example, there were dockside reports of canon-like explosions soon after a fresh shipment of elephant tusks arrived. Some tusks were said to have literally exploded into fragments in reaction to rapid temperature and moisture changes in the nighttime air of both New York and London. Other tusks, however, merely cracked. Most cracks in ivory are extremely fine; they tend to show as black lines from an accumulation of dirt and dust that falls onto any piece. Deeper and wider cracks often appear in older ivory—but they tend not to be uniform either in length, width, or the shape of the material in the exposed crevice.

 When ivory has been broken, it tends to split rather cleanly; it does not shatter, crumble, or splinter as bone is prone to do. As a result, ivory is often relatively easily repaired when broken. Because repaired pieces are generally less valuable than whole ones, care needs to be taken to determine if line cracks seen at joints and natural weak points are due to natural aging or artful repair work.

- Although there are grades of tusk ivory referred to as hard and soft, most of it is actually very *tough*—hard to nick or mar. All of the other principal ivory substitutes—with the exception of some plastics—are softer. As a result, indentations on smooth surfaces, without any discernible difference in coloration, are often a clue that the material may not be genuine tusk ivory.

- When visual inspection cannot firmly resolve the matter of authenticity, a hot *needle* test is sometimes used. I do not always have good results from this test and I am usually reluctant to employ it because needle holes mar a piece—even if the needle is applied in an inconspicuous place. In any event, a hot needle inserted in ivory should produce a charring effect. Ivory that burns turns black, but tends to retain its sheen. Importantly, it does not produce a noticeable ash. Plastic, on the other hand, melts under a hot needle and leaves no residue behind other than a few rounded burrs. Bone, when it burns, turns to a dull black and leaves a visible ash behind at the point where the needle was inserted into the material.

Determining genuine ivory is sometimes quite difficult. Each piece looks different because of the way it is carved, its coloring, its particular configuration, the use of paints, dyes, or other material with it, and the quality of the observation light. As a result, all of the above tests—save perhaps the use of a hot needle—should be employed when trying to establish the origins of a material. In my own case, I find the three most important factors in determining genuine ivory from everything else involve the following:

- Asking the seller or owner his opinion of the origin of the material used. The conversation almost always provides clues that feel and inspection can subsequently confirm or reject.

- Holding a piece in my own hands. If it somehow doesn't "feel" like ivory in terms of weight, temperature, and smoothness, most of the other tests will generally be to little avail in proving the contrary.

- If, however, it does feel right, then I always inspect a piece under a magnifying glass. The actual power of magnification is not as important as the need to narrow the eye's focus to a small enough area to concentrate on the material rather than on the carving or design itself.

Working with Ivory

Ivory's natural characteristics determine how it is carved:

- The tusk is hollow for about one-half to two-thirds of its length. At the root or base of the tusk, the walls can be anywhere from one-half inch (1.25 cm) to several inches (perhaps 7.5 cm) thick. As the circumference of the tusk begins to narrow, the walls become thicker. The solid portion begins when there is no longer a space between the two walls. This solid portion becomes denser and harder as it approaches the tip of the tusk.

- Despite outward appearances, tusks are never perfectly round. Rather, they tend to be more elliptical in shape throughout their length.

- Each tusk is also curved, but the amount and degree of the curvature varies. Gently sweeping larger tusks produce longer straight surfaces. One of the loveliest pieces in my own collection is a conductor's **presentation baton** awarded in the 1880s. It is about 24 inches (61 cm) long. Some 6 inches (15.2 cm) from the grip is an inscribed silver band. The remaining 18 inches (45 cm), however, are nearly straight—as a baton should be. But a discerning eye can still detect the start of a slight bend as the baton is tapered toward its tip. Despite this slight bowing effect, it is still one of the longest straight pieces of solid ivory I have ever come across.

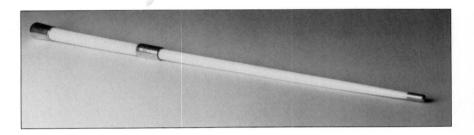

Artisans work ivory with sharp blades and chisels, as well as with saws, lathes, fine drills, and an assortment of files. Despite the fact that these are the same cutting and shaping tools found in any woodworking shop, ivory is said to be much closer to carving in *stone* than wood. To underline this last point, it should be noted that no one speaks of whittling ivory. On the contrary, the scrimshooners—those mariners who took to etching scenes on whales teeth or fashioning clothespins from whale bones—had to use a nail-like probe or knife end to incise a visible line or inscribe a point on the ivory they were working.

Because of its hardness and the difficulty of even intentionally marring an ivory surface, observers are constantly amazed to see ivory polished to a glass smooth surface or carved into a beautifully draped costume or drilled into delicate lattice-work backdrop. To create these effects, an ivory carver has to have the strength of a stone cutter, the finesse of a wood carver, and the eye of a painter.

He or she also has to have some wood-finishing material available. An ivory

artisan would likely have a variety of vices, emery papers, natural sands or powders, glues, oils, cleansers, and clothes to hold and polish the material to a finished condition. Because of its high cost, the initial cutting of a tusk has always been carefully designed to avoid wastage. Very thin saws are used with blades only 1/50th or so of an inch (.5 mm) thick. Even the ivory sawdust was collected in days gone by for making into a gelatin concoction and medicines.

Ivory used in veneers is peeled from the tusk, like the skin of an apple, in continuous sheets. Because of the natural pliability of ivory, sheets 30-inches-wide (76 cm) and up to 12-feet-long (3.7 m) have been stripped from a tusk, flattened, and then used in a variety of ways on wood bases. Some ivory is dipped in water to keep it moist during the carving and finishing process. This seems to be more a preference of individual artisans than a requirement of handling certain types of ivory. In past years, the manufacture of both billiard balls and piano keys required a steady bath of water to be played over the material when it was either on a lathe or under a saw. The water was used to reduce the heat caused by the friction of the cutting tools and blades; it prevented the ivory from cracking during the manufacturing process.

It must also be noted that ivory has been more a singular use material than other precious metals or stones. That is, once shaped into a design, it remains as such. Gold, silver, and jewels, particularly, on the other hand, may be formed and melted or recut several times. Now, of course, ivory gets recycled from its original use into something else because old tusks are difficult to find and most new ones have been banned from international trade:

- It is common today to see modern magnifying lens attached to the handles of old ivory knives, forks, spoons, and even parasols of a by-gone era. Sometimes, these same old ivory pieces make fittings such as knobs and handles or are reused to create new pieces such as photograph frames or pill boxes. *(See color photograph, p. 70.)*

- Some modern ivory jewelry—rings, tie tacks, studs, and cuff links, for example—is the result of carving the necessary shapes from the backs of discarded brushes, mirrors, and other relatively large, thick, and simple pieces of ivory from the past.

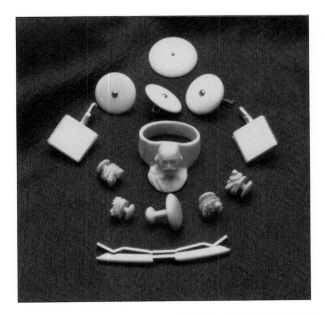

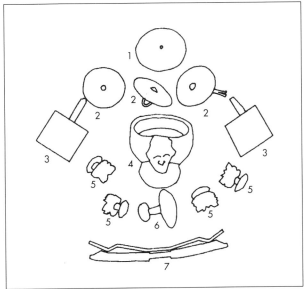

1	Button	4	Scarf ring
2	Stud set	5	Stud set
3	Cuff links	6	Collar stud

7 Collar bar

A few ivory works seen on the market today are actually fragments of larger pieces. In my own collection, I have the following pieces:

- A beautiful, lattice-carved, small oval bowl; the bottom is not perfectly flat. Because of this, it would appear to have been a part of a larger stand of some kind—perhaps to hold chocolates or nuts.

- A rather plain, but beautifully turned, candle holder looks to be the top of a more elaborate candelabrum—simply because of the good-sized dowel hole visible in its base.

I also have displayed in my collection a convex-shaped, two-inch, circular wheel with a little square button in the center. It is the kind of ivory fragment that is so intriguing to collectors and cultural historians. It appears to be either the side piece of a yo-yo or some kind of child's top; the perfectly concentric circles decorating the wheel seem to add a visual charm whenever it is spun. But given the placement of the button, the circles would be on the *inside* of a yo-yo and it is, in fact, very hard to spin as a top—the circumference is difficult to grip, the little button is very small, and the convex shape requires a perfect one-point landing to get a good spin started. The fact is that this little piece, despite appearances, is not a top at all. It is a fragment from a badly broken oriental statuette; the circular piece is actually a representation of a fisherman's straw hat and the button is part of the hat's conical design.

The subject of ivories—like any other collectible—is sufficiently complex that no one has all the answers to all the questions that may arise. Many of the most obvious answers, as in the case of the fisherman's hat, may prove to be wrong.

As with most things, the subject has to be approached with a fair degree of humility by those who have experience or knowledge. The rarity is in having an answer beyond contradiction. The fun, though, is in trying to divine an answer from any information that may be available about any particular object.

PRINCIPAL USES OF IVORY

As noted before, objects made of ivory have survived over the years while other materials have tended to fade or totally disintegrate. Our understanding of past civilizations has clearly been enriched by ivory. As one observer has noted:

> ...sculptured ivories [of the Gothic period] remain in such numbers that from them alone, we may learn the customs, dress, and domestic arts that marked successive centuries.

Historic Uses

The very earliest Western examples of the use of ivory seem to date from Egyptian civilization. Only a glance at objects found in Tutankhamun's tomb reveals a stunning number decorated with ivory, particularly in combination with ebony. ^ The contrast of black and white was obviously as appealing to Egyptians as it is to us. For example, the tomb yielded:

- An ebony box trimmed in ivory and apparently intended to carry records.

- A large throne chair with black legs and feet carved to resemble a lion's paws. Each paw is fitted with four perfectly proportioned ivory claws.

Most other ivory objects found from Egyptian times seem to have been carved primarily to decorate utilitarian items. In fact, ivory appears to have been employed by the Egyptians generally because it added beauty, rather

than value or longevity, to the pieces in which it was used. ^

The brilliant Nimrud ivories, which preserve information about part of the Assyrian Empire, date from a time nearly a millennium before the Christian era—a period when Egyptian civilization was no longer at its height. The Nimrud ivories were probably carved by craftsmen from such lands as Assyria, Phoenicia, and Syria—all of whom exhibited different styles and themes in their work.

These ivories, first found near the Tigris River in the 1850s and later excavated by succeeding British archeological expeditions, are all probably decorative portions of furniture used in a royal palace. The individual pieces—tables, chairs, thrones, and more—had rotted into dust, but the ivory decoration, veneers, and surrounding pedestal statuary have survived to give us an appreciation of this society.

We know that foreign dignitaries, accompanied by courtiers, paid continuous tribute to the Assyrian king. Like modern guests worrying about a gift that might please a host who appears to have everything, so foreign callers apparently brought the most magnificent gifts their artisans could create. The Nimrud ivories also include a collection of the heads of several ivory staves—all with different designs and knobs. The scholarly speculation is that these differences indicated both individual ownership and a particular rank in office. In ancient Rome, ivory chairs and septers symbolized the office and power of the chief magistrates. ^

Later in Europe, ivory objects were almost entirely religious in subject matter—depictions of Biblical stories and themes. The Salerno ivories, a series of small ivory panels divided into individual scenes of Biblical lore, is perhaps the most outstanding single example of these early Christian works in what one scholar has termed "...one of the favorite materials" of the early Middle Ages.

By the end of the Middle Ages, however, the use of ivory had broadened from merely a monastery art form:

> *Lay craftsmen had begun to carve holy figures and shrines largely intended for private devotion, to adorn the houses of the great and of the rich. In addition, they carved a large number of objects entirely secular in character.*

Beautiful cabinets, boxes, book covers, mirror cases, combs, brushes, and the like were being inlaid or carved entirely from ivory. Purely practical items made of ivory—because of the material's special properties as well as perhaps its mystical symbolism—were also favored by some. ^

In the Far East, for example, archers fitted circular, doughnut-shaped **rings**—made from both ivory and jade—over their thumb knuckle. This protected the most exposed part of their bow hand from being continually struck by the string once an arrow had been released toward its target. The use of ivory by warriors probably reflected its durability as well as the magical powers, many cultures associated with animal teeth.

As more and more ivory tusks made their way to Europe, the broadening process favoring more *practical* items continued. Objects employed in the everyday life of the wealthy—tobacco graters, drinking vessels, salt cellars, snuff boxes, and gaming pieces—were routinely either now being made from or embellished with ivory.

The reason ivory might have been chosen as the main material for any one of these particular objects is not entirely clear. It would seem, however, that color again played an important early role in why the material was used. Ivory white certainly offered a fresh clean look for these objects, and ivory, because of its scarcity, made them appear unusual as well.

As to the latter point, one scholar has put it this way:

> *...as the world was shrinking in the path of European mariners and merchants, so the treasure houses of kings*

and princes and the cupboards of the wealthy were being filled with new and strange objects [made from mother-of- pearl, coconut shells, rock crystal, agate, ivory and 'unicorn' horns] from India and China, Africa and the West Indies.

All the literature on fashion and interior design suggests that those who set the style and tastes 500 years ago were no less interested in change, new products, and fresh ideas than we are. As new materials arrived in Europe, so experiments would begin on how they might be employed or displayed.

It was not until the 19th century, however, that ivory came into popular use. One particular event—an unlikely event at that—seems to have been the catalyst for this explosion in the use of ivory. Coal-fueled steam energy allowed entrepreneurs to produce enormous quantities of new goods for greatly reduced costs and substantial profit. The rich entrepreneurs soon got even richer. Great wealth of the day was often expressed in the amount and kind of *leisure* available:

...no gentleman ever boasted of doing anything, no lady wanted to be caught doing what could be done for her.

To occupy themselves, three different activities became popular: playing billiards, learning the piano, and eating elaborate meals. It turns out that all three activities soon required an enormous amount of ivory. ^

Billiard Balls

Billiards seems to have originally developed in the 1400s as an attempt to bring the excitement and competition of lawn bowling indoors during the poor weather of winter months. Although some see billiards as a table version of either early croquet or shuffle board—because of the use of a stick to propel a projectile—the principal object of billiards, just as the object of lawn bowling, is to strike one ball with another rather than to hit a stationery target or goal.

Whatever its actual origins, the game of billiards became very popular among noble and royal families. The Court physician at Versailles is reported to have recommended to King Louis XIV that he play billiards

every day for its salutary effects on his health. Mary, Queen of Scots, was said to have complained to Queen Elizabeth I about the loss of her billiard table during her imprisonment. Soon after airing the complaint—but not apparently because of it—Mary was beheaded.

Over the centuries, refinements in the game came slowly. Then, in the 1790s, a Frenchman dazzled regal Europe with a demonstration of trick shots he had practiced while *he* was in prison. Interests in billiards started to increase. A few years later, an Englishman put some chalk on the leather tip of his cue stick to prevent slippage when striking the cue ball. This simple change permitted shooters far greater control of the speed and direction of their initial shots. As a result, something called "english" was added to the game as many more different shots came within reach of even ordinary players.

Enthusiasm for the game jumped once again when slate was substituted for wood—providing a perfectly level and smooth base for play. Later, the development of rubber side rails permitted carom shots to be undertaken with consistency. At this stage, the game began to take on the characteristics of an emerging craze among aristocratic and wealthier elements of Western societies.

A finished 19th century billiard ball perched on a segment of a heavily-barked and clearly grained tusk.

The game's popularity was probably abetted by the need to find something to occupy the enormous amounts of free time some people had on their hands. Leisure, in the mid-19th century in England, had become a way of life. To be idle, it should again be noted, demonstrated great wealth. But idleness also required an enormous effort to avoid boredom. In such an atmosphere, billiards became one popular way to occupy the free time so many people were working so hard to accumulate. When the Hotel del Coronado in California opened in 1888—designed to be "the talk of the Western World"—it boasted 750 rooms, an 11,000-square-foot (about 1000 square meters) ballroom, and *30* billiard tables, four of which were reserved exclusively for the use of ladies.

Balls made from the ivory of an elephant's tusk soon became as much an integral part of the game as the felt covering that was stretched over the slate. Each billiard table required at least three perfectly round, completely solid, unmarred ivory balls—about 2-3/8 inches (6 cm) in diameter. At the beginning of the 1890s, more than 100,000 pounds (49,000 kg) of ivory were turned into billiard balls.

Tusks for making these balls were principally acquired in Antwerp and sold in lots of 50 tusks. Commentators have said that only a dozen or so of the tusks in each lot could be expected to be suitable for the manufacture of first class billiard balls. Not only did the use of ivory itself make the balls expensive, but the time of manufacture also added to the ultimate cost. Once a ball was cut into shape, it had to be shellacked and seasoned for some 18 months to two years before it was thought to be dry and hard enough to be used in play. Even then it might not always roll true—either because of a defect in the manufacturing process or because of a rapid rise or fall of temperature during the seasoning period. In addition, after considerable play and normal abuse, ivory balls tended to become discolored, cracked, and otherwise marred.

Later, the demand for ivory intensified when different versions of the game developed—the U.S. game of *pool* and the British game of *snooker*, for example. Both of these require more balls—16 in the case of pool and 22 in the case of snooker. Significantly, both games added pockets to the table—the pockets becoming targets into which the balls could be directed. The cost of providing ivory balls for these newer games—even though the balls themselves were smaller and took less abuse—was one thing. A question of sheer supply of balls was another. Were there enough suitable elephant

tusks available for the manufacture of so many balls?

John Wesley Hyatt was an American printer. He began a search for a material that could substitute for ivory in the manufacture of balls for billiard-type games. Hyatt, interestingly enough, wasn't looking for a way to make *cheaper* balls. He was after a *better* ball—one that would not be affected by nature's quirks, sudden shifts in the weather, or by the effects of use. He got it when in 1868 he discovered that nitrocellulose (a natural by-product of wood), after being mixed with camphor and a little alcohol, became soft and pliable (thermoplastic) when heated. In this condition, the material could be molded into any desired shape that became permanent, hard, and strong when later cooled. The ball that John Hyatt produced indeed proved better than natural ivory balls for the games of pool and snooker. Striking one ball into another to drive the second into a pocket did not require the ball to react in quite the same way as demanded in the no-pocket, carom version of the game. Most of all, these celluloid balls did not chip, crack, or change shape in different temperatures.

Even though Hyatt intended only to create a better ball, he also got a cheaper one in the process. That changed both the economics and the culture of the game. When bar equipment manufacturers began making the tables and installing them in saloons for added profit, the game of the nobility soon also became associated with lower elements of society. The seeds of the end of a cultural fad were thus sewn.

It should also be noted that in John Wesley Hyatt's search for a better billiard ball, he gave the world its first *synthetic* material for manufacturing use. Historians of thermoplastic materials point out, however, that Hyatt's discovery of celluloid altered a *natural* material with some simple chemicals. It was not until a Dutch-American scientist named Leo Baekeland created a resin out of phenol formaldehyde in 1907 that the world had a *totally* synthetic material at its disposal. When the celluloid billiard ball was itself eventually replaced by a ball made from Leo Baekeland's new material (called *"Bakelite"*) and when white piano keys were also formed from this new synthetic, the age of plastics had arrived.

Despite this progress, ivory alone continued to be demanded by the best of the cushion billiard players. In this game the object is to use one ball to strike the other two with a ricochet effect in order to score a point and retain the

right to continue playing. Ivory balls apparently reacted in a way that no plastic material was then able to duplicate. Players liked the fact that an ivory ball rolled precisely the same distance every time it was struck with the same force and that one ball would tend to bounce off another with a uniformity of direction and a consistency of reaction.

The more people who took to playing this original (French) version of the game of billiards, the greater the demand for ivory balls. The fact that these balls could only be made from the solid ends of certain elephant tusks was of no concern. The price was simply paid. The demand became so intense that middlemen in Africa and some dealers in Antwerp saw easy ways to cheat. They took to stuffing lead into the tusk cavity to make the tusk weigh more. Tusks that were stuffed also seemed to have larger solid portions. Buyers tended to pay premium prices for these tusks in the hope that they might yield more manufactured balls. ^

Manufacturers also tried to squeeze more balls out of the narrowing ends of any tusk they had purchased. This sometimes left bark and crust marks from the outer layer of the tusk on the finished ball. These balls, however, sold at a lower price than the pure white balls coveted by the wealthiest and most uncompromising of players. The price of the perfect white ball was about $16 in the 1890s—or $48 for a set of three. By comparison, a gentleman might buy five different hats in Iowa for the cost of one billiard ball or he might acquire more than 40 acres (about 16 hectares) of land in Oregon for the equivalent of a set of three.

Of course, when people are willing to pay a steep price for their pleasure, many other elements of society often suffer. In the case of the African elephant, a whole species was threatened. Elephants were now being hunted specifically for their tusks. No longer was the ivory from elephants merely a profitable by-product of an animal's death from natural causes or as a result of a native tribe's need for food.

> One of the great stories of this era was how Henry Morton Stanley, an intrepid British-born, American-trained reporter for the *New York Herald*, went in search of a famous English missionary and explorer who had been missing in the African jungles for eight years. Stanley did not know the man he was looking for. Yet his simple greeting to the first white man he came across—"Dr. Livingston, I presume"—has become the classic example of British understatement.

His discussions with David Livingston also helped to change Stanley's career from newspaperman to African explorer. What is little known about this episode is that Livingston had been in Africa to convert the natives to Christianity, to map the continent, and to stop slavery. The latter goal deeply involved Livingston in the ivory trade. He was searching for interconnected navigable rivers to transport ivory—and thus obviate the requirement for wars to capture slaves to carry the tusks out of the jungle for Arab traders to sell to the world.^

Like many other social fashions or cultural fads, billiards eventually lost its great appeal. World War I, when men were called to other duties, provided the impetus for change. After the war, social activities with women must have seemed much more meaningful and interesting to the returning military personnel than being confined in some single-purpose room with other men playing a table game. Perhaps equally important to the decline of billiards was the post-World War I competition for leisure time from a whole host of new devices. The radio, the phonograph, motion pictures, and the motor car each offered a new way to spend free time. Billiards had to seem much less appealing to many.

The result of this change in attitude was a significant reprieve for the African elephant. It came at a time when the highly favored smaller tusks (called *scrivelloes*)—those whose solid ends were only slightly larger than the intended circumference of a finished billiard ball—were proving hard to acquire. The larger tusks not only caused greater waste, but were much more difficult to work into perfect balls. Moreover, the smaller tusks tended to come from elephants of breeding age.

Finally, the improvement of synthetic products was such that when billiards returned to popularity in the 1960s and 1970s, ivory balls were no longer required to play the game properly. New plastics, often referred to simply as "composition material," were by then in use.

Piano Keys

In the growing middle classes of the Victorian world, young ladies were given only one task to accomplish after they had completed their formal

schooling: obtain a husband.^ An air of innocence and genteel accomplishment—particularly in music—were thought to be crucial to winning a man's heart. Modern psychological research even suggests that the Victorians were on the right track. "...those who study music show more leadership skills, poise, vigor and self-confidence than those who don't." Moreover, studying music through the piano seems to be as popular today as it was in the 19th century.

There was a reason that the piano, in particular, was held in such universal regard. In the words of one authoritative source, the piano "...put instrumental music into every home..." because of its simplicity and vast musical range. Interestingly, the development of a piano that took *vertical*, rather than *horizontal*, space in a living room gave the middle and upper middle classes an opportunity to have an instrument that previously only the rich had sufficient space for:

> *In the new suburban villas...the upright piano with its*
> *fretted or inlaid front and twisted candelabra was the*
> *focus of the drawing room.*

On both sides of the Atlantic, the piano soon became a symbol of financial success. In 1876:

> *There were more pianos in American homes than there*
> *were bathtubs; they were second only to the kitchen*
> *range as an [American] status symbol.*

Around the same time, America had some 157 piano factories producing about 25,000 pianos a year to meet the market demand. Albert Bolles noted that "the American piano [and] organ... are conceded the best made in the present age of the world."

The keys of nearly all of these instruments were made of ivory. It was claimed at the time that no other material could be polished to a silky smooth surface capable of also absorbing the perspiration of the performer. (Before the era of air conditioning in concert halls as well as private homes, the problem of perspiration interfering with a player's control of the instrument was obviously greater than today.) Moreover, ivory lasted a long time and looked uniformly beautiful with wood finishes—just as it did in

Tutankhamun's time.

As most people know, each piano keyboard consists of 52 white keys among the 88 total keys. Each is about 6 inches (15.2 cm) long and two inches (5 cm) wide at the base. It is estimated that every piano keyboard required a pound and a quarter (about .5 kg) of ivory. Even so, only a veneer of the material was used. A thin layer of ivory was fitted over the top and ends of the keys; the sides were not covered, and the underlying wood could sometimes be seen as individual keys were depressed. The white keys, as piano players well know, come in three shapes: two look like either a lower case "h" or "d"; the third shape resembles a gavel standing upright on its hammer.

On some older pianos, the face of each of these key shapes was cut in one complete piece. In the majority of models, however, the top and bottom portion of the keys were two separate pieces of ivory. The top, narrow portion of each key was about 4 inches (10 cm) long and 1 inch (2.5 cm) wide, and the fatter bottom part measured about 2 inches (5 cm) square. But even these relatively modest dimensions, in veneer-thin portions, could still consume a lot of ivory. In 1870, for example, some 35,000 pounds (about 16,000 kg) of elephant tusks were needed to meet the demand for piano keys

Ivory keys on a 1930s-era Steinway baby grand piano.

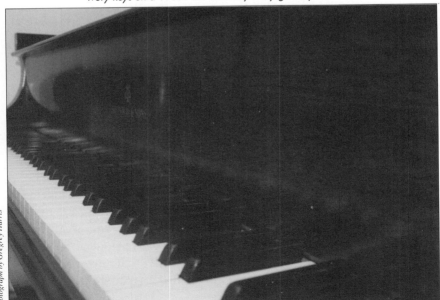

Photograph by Gregrey Harris

THE FASCINATION OF IVORY

alone. By 1913, the annual demand had grown to the point that nearly 450,000 pounds (about 200,000 kg) of ivory—the life's output of some 4000 elephants—were required.

Ivory soon became as much a part of the piano as it had become part of the game of billiards. In fact, the expression "tinkling the ivories" arose as another way of saying that someone was playing the piano. But just as celluloid was developed to make a better billiard ball, so another plastic was developed to make a better piano key. That plastic is today called *Implex*. It is said to embody the appearance, feel, and durability of ivory, but to have none of that material's faults. The claim of piano manufacturers that Implex never turns yellow, can be made in one piece, and neither cracks, chips, or splits.

One of the ironies of understanding and appreciating ivory is that synthetic substitutes were developed to do a better job than the natural material. Yet when promoters of the new synthetics describe their substitute, they invariably return to words that describe a natural material. Implex advertising copy talks about the feel of *silk* and the wear of *iron.*

Tableware

During the reign of Queen Victoria, knives, forks, spoons and other items of tableware came on the market in enormous numbers.^ Prior to this era, few poor families could afford dedicated utensils for tableware. They used the same knives, forks and spoons for eating as they did for cooking, holding, stirring, cutting, gripping, and scooping. In wealthier households, hosts might provide guests with knives (from an elegant knife box that displayed the handles and protected the blades); the knives cut, scooped, and stabbed in conjunction with fingers. No other utensil was needed. Even 18th century travelers learned to carry their own knives and forks because inns of the day did not provide guests with either when meals were served.

With the growth of the Victorian middle classes, however, a whole new element of society started to devote itself to the *culture of eating*. In fact, the very hours for dining changed dramatically in London. Now eating came later in the evening to reflect the importance given to what was being transformed from a necessity to a new leisure activity. It also soon became fashionable to provide guests with a full panoply of eating utensils. Gold,

silver, and pewter, particularly, were used for the handles of tableware items. Another popular material of the day for knives, forks, and spoon handles was mother-of-pearl. While enthusiasm for things made with or from mother-of-pearl can be associated with the popularity of a major Oriental exhibit at the 1851 Great Exhibition, it is less certain why ivory tableware became equally fashionable at the same time.

Gold, silver, and pewter, of course, had not lost their appeal so much as ivory—another precious material of acknowledged value—was now more *available*. And it was available at prices the growing middle classes could afford. It may be that some of the attraction of ivory for utensils can also be traced to the following factors:

- Scrap ivory—the hollow part of the tusk unusable in the manufacture of billiard balls—was now in massive supply. As a result, artisans could use a luxury material in their everyday products without raising their prices to the level that gold and silver would command.

- Unlike wood, ivory did not rot in water and unlike bone, it didn't tend to break. Unlike pewter, it was consistently attractive. As a result, ivory-handled utensils could be used meal after meal without losing their original appearance.^

- It could also be that the popularity of billiards at the time—ivory balls being the most consistent element in the game—carried over to other elements of society anxious to identify in some way with the wealth that was implied in playing billiards.

In fact, ivory was probably an affordable "best" set that would also survive everyday use by middle class families. They would not need to go to the expense of acquiring or storing another complete set of cutlery made from gold or silver.

Whether because of its sudden abundance, its preferable qualities, or its momentary place in fashion, enormous numbers of ivory tableware pieces were manufactured. It wasn't the number of sets so much that appeared, but the quantity of *pieces* in each one that seems so staggering today. Families apparently wanted to demonstrate what they could afford. Those who had been to the Great Exhibition of 1851—and some 6 million (about 20% of the

population of Britain at the time!) attended—came away with new ideas and new ambitions and with a desire to have more comfort in their homes, more luxury around them, and as much leisure as possible.

While poor families might have made do with one type of spoon, the emerging middle classes could now insist on a different spoon—each with a distinctively shaped bowl—for every type of food served. Depending on the provisions a cook might find available in the markets and shops on any given day, hostesses now felt that they had to be prepared with the following array of different kinds of spoons:^

- Soup spoons
- Bouillon spoons
- Tea spoons
- Coffee spoons
- Salad spoons
- Vegetable spoons
- Grapefruit spoons
- Orange spoons
- Berry spoons
- Sugar spoons
- Salt spoons
- Mustard spoons
- Ice cream spoons
- Bonbon spoons

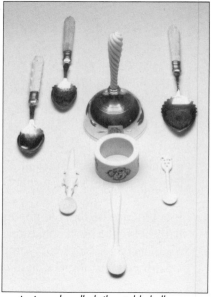

An ivory-handled silver table bell
and ivory napkin ring are pictured here with
a variety of different spoons.

Some of these spoons, of course, were for serving purposes and would not be duplicated at each place setting. A service for 12, however, could create a minimum need for some 96 ivory handles for *spoons* alone. While the size of each spoon bowl differed according to its intended use, the size and design of the handles tended to be identical. Some of these handles were perfectly plain; others had fluted motifs or ornate decoration carved on them.

The more elaborate the handle's design, the more raw ivory each handle required.

Of course, in addition to 96 spoons in a set, even more ivory-handled *forks* were required— forks for bread, for cake, for cold meats, for hot meats, for fowl, for fish, for salad, for asparagus, for pickles, for sardines, for dessert, and for fruit.

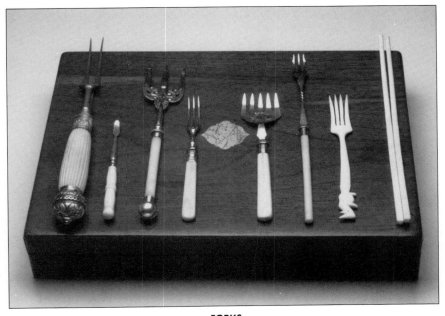

FORKS

| Carving | Nut | Bread | Fruit | Meat | Pickle | Salad | Chop Sticks |

Knives were also profuse. But knives were differentiated by the shapes of their blades, more than spoons were distinguished by their bowls or forks identified by their tines. Since the various shapes do not seem to have any discernible bearing on the knife's ability to cut different kinds of foods, one can only assume that the shapes seen at each place setting gave guests a clue as to the amount and variety of dishes to be consumed at that particular meal.

It must have been a daunting sight, then, to see knives for butter, fish, fowl, fruit, steak, meat—and more—on parade to the right of each place setting. The standard for such matters was set by the Royal family:

> *[The Regent would return to the Brighton Pavilion from the races to a meal of]... dish after dish piled high with tasty concoctions of fish, meat and poultry and sweets bubbling over with chocolate and cream...*

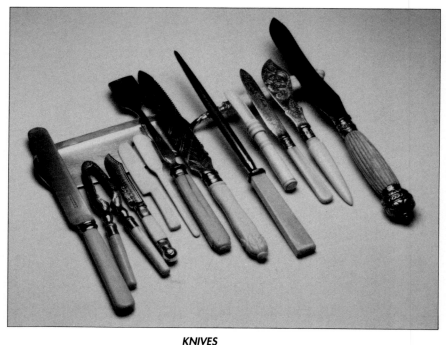

KNIVES

Meat	Butter	Measurer		Bread	Apple Corer		Fish	
	Nuts	Paté	Cheese		Sharpener	Fruit		Carver

By Victoria's time, middle class eating seemed to go even beyond what the Regent and his entourage consumed. What birth or marriage had failed to provide some families in the way of titles and status, wealth might yet give them. It is reported that a middle class dinner party in the 1850s might begin with soup and a fish course before venturing into a few side dishes such as asparagus, cucumbers, or sliced tomatoes. Once these preliminaries were out of the way, the guests would move into the serious business of roasts and

fowl. These courses would always be followed by sweets and savories, desserts of fruits and nuts, bonbons, sweetmeats, and cakes.

Is there any wonder that complete sets of ivory utensils also seem to have come with matching serving pieces and a variety of specialty items such as:

- Carving knives and forks for meat;
- Carving knives and forks and sometimes shears for fowl;
- Fish slicers and companion forks;
- Knife sharpeners, cork screws, napkin rings, and dinner bells;
- Tomato and cucumber forks;
- Pie and cake servers;
- Nut picks and nut crackers;
- Tongs for sugar, for ice, for olives, and for bonbons;
- Scoops for cheese, for marrow, for sugar, and for tea;
- Ladles for soup, for oysters, for gravy; and
- Coffee and tea services, each with ivory-handled sugar bowls

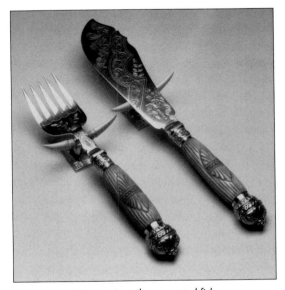

Presentation silver-mounted fish servers on ivory and silver rests

and milk or cream pitchers, strainers, hot water containers, slop bowls and other items all perhaps on a matching tray.

The list is nearly endless and it is partly why so many pieces of ivory can still be seen today in antique markets. A lot of pieces were made for each of these sets, but the sets have been broken up over the decades. The separation has not necessarily been malicious—pieces would get lost or damaged, others would be cannibalized, and the resulting incomplete sets would be given away or sold.

Yet any one of these ivory-handled pieces today can make a lovely gift and find a suitable current use. We may not set a table with a pickle fork at each place, but any one of these forks can be used on a modern buffet table. In the same fashion, fish knives, with their distinctively shaped swooping blades, can be used today as spreaders for soft cheese, dips, and butter.

Conclusion

For thousands of years, a few wealthier individuals seemed to take delight in what an artist or craftsman might make from an elephant or mammoth tusk. Whether these pieces of ivory were for decorative display, for religious purposes, or for personal uses, they seemed to have been greatly admired.

Then in the 18th century, new sources of energy were developed which freed man of many simple, but time consuming, tasks. Those energy sources permitted the development of enormous quantities of new wealth. Wealth, at the start of the 19th century, was evidenced by the availability of leisure time to entertain and enjoy oneself; work—whether for profit or service— was to be avoided, not sought as it is in modern times. It seems incredible now to think that this desire to be able to do *nothing* would lead to a re-emergence of an interest in billiards and spark a need to know how to play the piano and that both of these enterprises would require an enormous amount of ivory. From this demand came an excess supply of material from which tableware and a host of other products could be made.

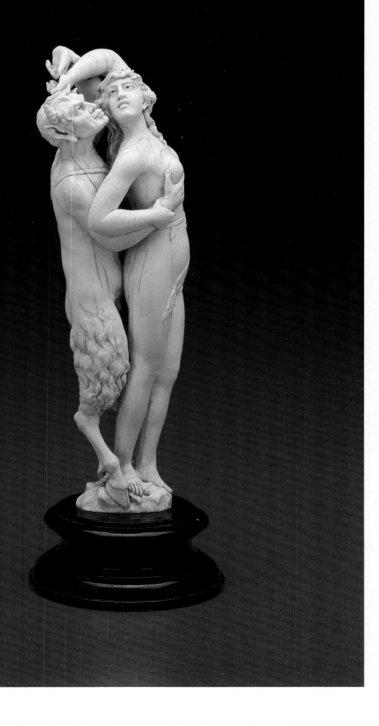

EXQUISITE ARTISTIC EXPRESSION is seen in this classic 18th century ivory carving of Pan, the Greek God of Fertility, embracing a nymph.

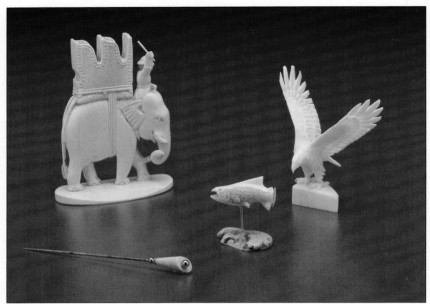

DIFFERENT TYPES OF IVORY were used to carve the eagle and salmon (walrus ivory), the elephant (elephant ivory), and the stick pin (mammoth ivory).

IVORY'S ABSORBENT QUALITIES AND HIGH VALUE
made it an ideal material to hold cosmetics and an inviting surface for oil paintings.

SCRAP IVORY, the residue from the manufacture of billiard balls, enhances hundreds of different objects: Here an 1830s sugar scoop (top) from a home and an 1870s eyelid retractor from a doctor's surgery.

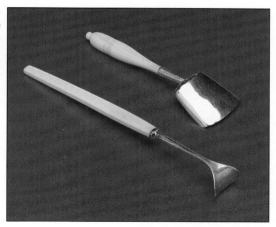

IVORY DECORATES this Victorian seal, used to authenticate documents and discourage unauthorized review, with a beautifully carved fantail pigeon.

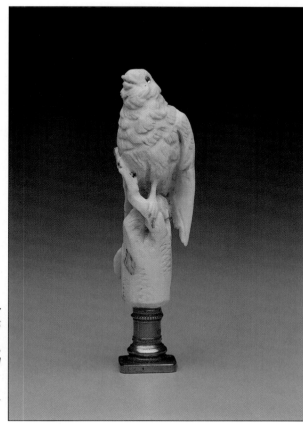

THE FASCINATION OF IVORY

SUBSTITUTES FOR GENUINE IVORY abound: Celluloid (the 1927 presentation fan) was invented in a quest for a better billiard ball; antler (the silver mounted knife rests) was often used for masculine accessories; and bone (the pill box) was employed when tusk ivory was unavailable.

IVORY COMBINED WITH OTHER MATERIALS enhances the appeal and value of objects. Here (clockwise from top): A portfolio case (with wood); a back scratcher (with bamboo); a fly whisk (with horse hair); a collar stud (with gold); a bottle stopper (with cork); a dollhouse bust (with marble); and an inkwell (with tortoise shell.)

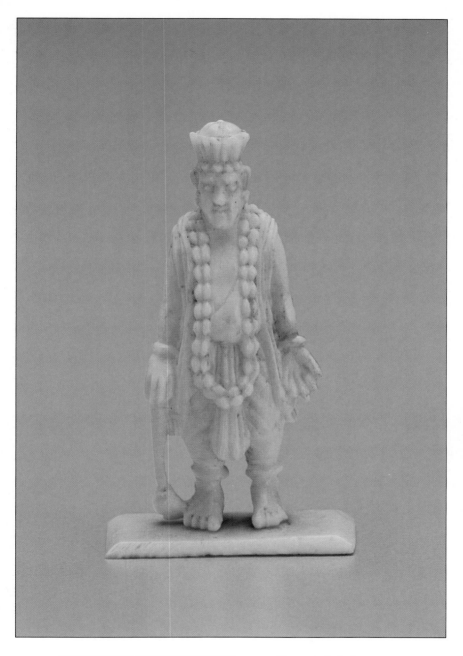

SCULPTURES RENDERED IN MINIATURE are one of the particularly charming uses of ivory. Here a 1.25 inches (3.2 cm) tall Polynesian king, probably carved in Dutch Indonesia in the early part of this century, is seen with the chains of his office highlighting an ample, Bhudda-like belly and pantaloons stopping just short of his bare feet.

THE HEAT ABSORPTION QUALITIES OF IVORY *made the two carved grips on this Victorian teapot more practical, while enhancing its aesthetic charm.*

RECYCLING FINE IVORY *objects is now common. Parasol handles are often used for newly ground magnifying glasses, and old cutlery handles are joined to modern cheese slicers and knives. The odd fish knife has become a buffet table serving piece.*

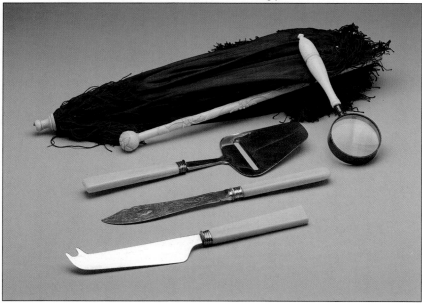

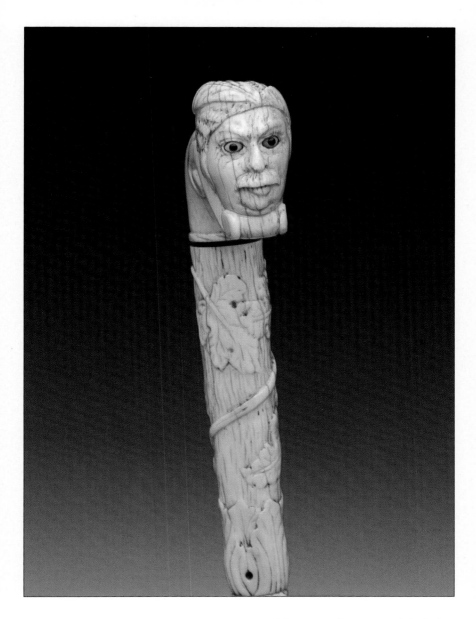

THE RELATIONSHIP OF IVORY TO WATER—*not only because teeth are constantly bathed in moisture or the sea journey taken by African and Asian elephant tusks to their principal markets, but because of whale, walrus and nahwhal ivory as well—is reflected in this 18th century whip handle patterned after the prow decoration of a sailing ship.*

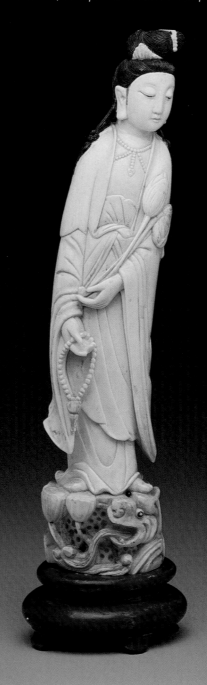

IVORY'S SPECIAL QUALITIES—its inner glow, its rich color, its smooth texture, and its extraordinary resilience—are all exhibited in this post World War II painted carving of Kwan-Yin, the Japanese Goddess of Compassion.

PERSONAL USES OF IVORY

In determining how newly imported elephant tusks were to be apportioned for the manufacture of billiard balls, piano keys, and tableware items, ivory craftsmen were careful to cut their raw material artfully to lessen wastage and to preserve as much usable ivory scrap as possible. This excess material provided an opportunity to create a virtual cornucopia of ivory items. Before the 19th century, pieces made from or embellished with ivory could be acquired only by the very wealthy. Often, other materials were used to substitute for ivory. Then in the second half of the 19th century, ivory objects came within the grasp of the middle classes for the first time.

Of course, not all of the ivory items made during the period were carved from what was essentially "scrap" material. Because many tusks imported into Europe were rejected as inadequate for the manufacture of billiard balls, artisans could start with whole fresh tusks for the first time in creating objects for their private patrons or the public in general. Whatever the origin of the raw ivory used, though, three categories of ivory objects seem to encompass the *personal* uses of this material. As such, ivory was being made into a profuse number of:

- Individual accessories;
- Jewelry; and
- Toilette articles.

Some of the more unusual ivory items in each of these categories are discussed in the sections below. Nearly all of the examples used are drawn from my own collection or observations. As a result, the discussion is not intended as an encyclopedic listing of the different *uses* of ivory. For one

thing, my collection is not all inclusive; for another, the discovery of new items made from or embellished with ivory seems never ending. The discussion that follows, then, is more an informal exploration of some of the more important aesthetic, mechanical, or cultural forces that may have contributed to the production of these different types of ivory pieces.

Individual Accessories

Individual accessories can be described as those items men and women of comfortable means of the Victorian era took to carrying with them when away from their homes or for particular occasions.

In Japan, for example, a little accessory called a *netsuke* (pronounced "*nets—key*" and always singular in form) was transformed from a utilitarian item to a reflection of a man's position or beliefs during this era. Since kimonos have no pockets, Japanese gentlemen carried small wooden and lacquered purses, called *inro*. Originally the inro was only intended to carry a gentleman's personal seal. Later, however, it was divided into sections and adapted to carrying drugs, perfume, money and tobacco. To secure the inro around the *obi*, or kimono sash, two strings were attached to a toggle or counterweight. This counterweight device was known as a netsuke, from a word meaning root.

Netsuke were originally carved from wood; they were strictly utilitarian objects—"to be worn, wornout, and discarded"—as one writer notes. Their size depended on the weight of the purse or the proportions of the owner. But with the introduction of tobacco by the Portuguese, smoking became fashionable for merchants and a sign of success for men not of the samurai class. Fancy netsuke were demanded to match the elegance of the tobacco paraphernalia being carried.

The fanciest netsuke were carved from fine wood as well as from marine ivory—the tusks of walrus or narwhal or the teeth of a sperm whale. It appears that the reason ivory was used for netsuke was a matter of circumstance, rather than purposeful design. Most of the best miniaturists at the time that fancy netsuke were first being demanded just happened to live in places where marine ivory was plentiful. They naturally used this material because they were familiar with its properties and because of its general availability.

But it is the *subject* of each netsuke, rather than the particular material used, that gives them their charm. It is also the extraordinary detail of the workmanship that gives them their special artistic merit:

> *Ranging in height from only an inch or two...many...displayed eyebrows, fingernails, eyes, and pupils inlaid with tiny bits of [translucent] coral or horn.*

Soon netsuke came to represent "the fables, fashions, and fancies of the unique and inward looking society which developed during Japan's 150-year seclusion [from the rest of the world]." With the reopening of Japan to

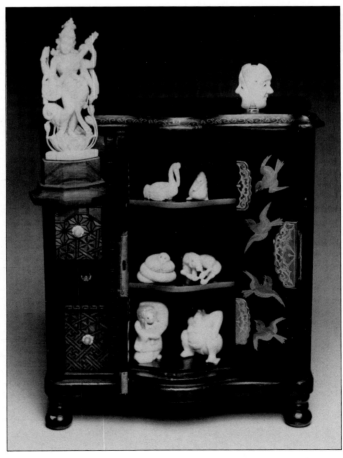

A variety of modern netsuke on display in a Victorian jewel cabinet watched over by Vach, the Indian Goddess of Learning.

the West in 1853, Japanese gentlemen soon took to wearing western style suits with pockets; the need for netsuke quickly disappeared. ^

Just as ivory became one of the most popular materials for netsuke in Japan, it also became increasingly fashionable to use ivory in the making of personal accessories in the West. Ivory seemed to fill an important place for patrons who couldn't afford to have personal accessories made from or with precious metals and jewels and yet wanted something that would last longer and look richer than ordinary woods and baser metals. For example, such personal accessory items as opera glasses, magnifying glasses, eye glasses, change purses, calling card cases, note pads, lockets, picture frames, prayer books, crucifixes, parasols, riding crops, walking sticks, and much more were made from or with ivory.

Any one of these items helps to illustrate what life in the Victorian era was like. It was an era, by the way, that does not coincide precisely with the reign of Queen Victoria—despite its name. Victoria came to the British throne in 1837 and ruled until 1901. The *era* associated with her name, however,

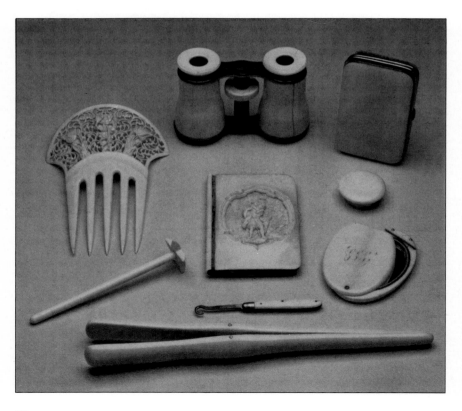

generally begins in 1851 and does not actually end until 1914. Before 1851, English society was still more attuned to the social dictates, habits, and manners left over from Victoria's father—an era known as the Regency period. The Victorian era actually seems to have been ushered in by the opening of the Great Exhibition in Hyde Park in London. It would finally end with the start of the First World War. ^

One of the central aspects of social life for the growing middle classes in the Victorian era was the Church. Attendance each Sunday was expected. It also became a favored time for the men to demonstrate their financial success by parading their families before peers and the rest of the congregation in new clothes and fancy carriages. One of the prized accessories that many of the young women of the day would carry with them each Sunday was a personal *Bible* or *prayer book*. Some of these lovely, delicate books were bound in ivory.

Here the reason for the use of ivory instead of leather or any other material— at least for patrons who could afford better things—seems clear. Ivory's

1	Opera glasses
2	Coin purse
3	Compact
4	Mirror
5	Glove stretchers
6	Champagne swizzler
7	Hair comb
8	Calling card case
9	Button hook

white color symbolized purity, and an ivory-clad Bible or prayer book was a popular communion gift for young women of the day. In addition, of course, ivory has always been associated with survivability. Ivory could convey a lasting strength to match the everlasting strength of the words inside. As if to prove these points, the books seemed to have been more for show than for piety. Few of them available today look like any of their pages were ever actually disturbed by their owners.

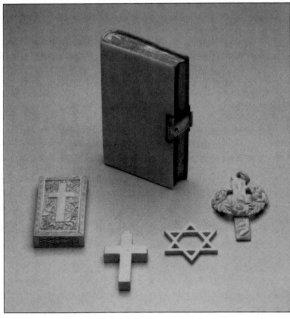

Religious items include (clockwise): Anglican prayer book; Coptic cross; Star of David; Christian cross; and child's confirmation puzzle (the pieces inside the box form a cross.)

If the elegant families of a particular congregation were joining another family for luncheon after church services, each of the ladies would likely also be carrying a *calling card case* in her handbag. These cases held elegantly engraved cards—most of which only revealed the name and title or honorific of the owner. Cases carved from ivory, with blue or gold silk covered dividers inside, appear to have been enormously popular. (*See photograph, p. 76.*)

The calling card was originally intended to be given to a servant to announce a person's arrival at a home or office. But over time, unannounced calls became rare as formal invitations for every imaginable event became fashionable. Hostesses soon came to know precisely who would be arriving at their homes at what times and on what days. Despite reality, every lady still carried and exchanged formal calling cards. A habit emerged of ladies leaving their cards at the conclusion of a visit on a tray set out on a table in the entrance hall.

The protocol of card leaving soon became particularly elaborate—one card for each adult lady in a household, provided, however, that no more than three cards from the same person were left. Then, of course, only one card was to be left when the caller was not personally received—no matter how many adult ladies in the household—with the corner turned down if it had been left in person, rather than delivered by a servant. Notes were often written on cards to extend informal invitations, to express thanks, and to accompany gifts. The etiquette became so intricate that knowing the ritual of calling cards became the "mark of good breeding."^

Soon, it seems, no one wanted to violate the complex etiquette of calling cards for fear of being judged uncouth or ignorant. Yet by the time the cards achieved the status of ritual, they apparently served no other purpose than to demonstrate a person's breeding or eligibility to be included in a particular level of society. Men, on the other hand, used cards in business. They tended to have both names and addresses engraved on them. But they were tiny compared to a woman's card—and the ivory cases for each were sized accordingly.

A few other ivory accessory items are worthy of discussion in some depth—in terms of the workmanship of a particular article as well as what they tell us about life in the society that used them and how different our lives have become without a need for them. Take the *fan*. It was perhaps the most common accessory made out of ivory for women of the Victorian era. Ivory was often used for the end pieces as well as for the intervening struts that linked beautiful pictures painted on silk, paper, linen, and other materials.

In some fans, the blades themselves were made of ivory. The variety of wonderful patterns or scenes carved and drilled into eachis worthy of considerable study and admiration. Fans came in a wondrous variety of sizes—the size dictated by the time of day and the place they were to be used. Fans became such an important aspect of society that an entire non-verbal language was created for them. Ladies who were forbidden to speak to strangers—particularly men who had not been properly introduced—soon learned how to communicate with them using their fans.

One enterprising person even patented a communication system called *Language of the Fan* in April 1879. Here is a sample of what men were instructed to look for:

• If the fan were carried in a lady's right hand, immediately in front

of the face, it was said to mean "follow me."

- If the fan were twirled around the same right hand, the man was being sent a dear John note: "I love another."

- But if the fan were being carried in the left hand, the lady was saying that she wanted to make the man's acquaintance.

- On the other hand, if it were being *twirled* around the left hand, the man was being told "I wish to be rid of you."^

Whatever the non-verbal communication with a fan, one that has always fascinated me is in my own collection. It is as functional as a fan can become—in both circulating air and in its compact configuration when furled. The fan is completely circular when unfolded and totally devoid of decoration. It consists of just 11 tear-shaped, translucent ivory leaves held together by two narrow strands of silk. The blades are attached to two identical, tear-shaped ivory handles.

I have this particular fan displayed near another circular fan. The second one is made of celluloid. Rather than waving the blades in front of the face, the blades of the celluloid fan are turned by a little spring-driven motor activated by depressing a thumb lever. When the lever is plunged inward, the three blades whirl into action and spin for perhaps 30 or 40 revolutions before requiring a follow-on push to keep the spinning going.

The two fans live particularly well together in the collection. The circular ivory fan, made in France, shows a beautiful precious material, without any decoration, being put to a purely functional use. The circular celluloid fan,

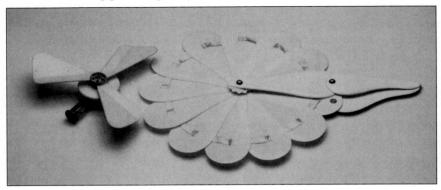

Mechanically-driven celluloid fan rests alongside a lady's ivory circular French fan.

made in England, shows a thoroughly plain ivory-like material, being put to a mechanical use. Both do the same job. There is no doubt that the latter does it better with less human effort. But the celluloid fan has almost no charm. That, it seems to me, is representative of what human progress has often brought us—improved function at an aesthetic cost.

Among all the accessories made from ivory in Victorian times, the use of *tobacco* seems to have inspired the most paraphernalia. I have not yet added an ivory-stemmed pipe tamper to my collection, but I do have a variety of cigarette holders, snuff boxes, cigar cutters, and match boxes. I even found an ivory ashtray in a shop in New Orleans just days before committing this book to the printer.

To understand why smoking accessories were so numerous requires an understanding of the social place of tobacco in Victorian times. While the taking of snuff had long been well-established among the British upper classes, the *smoking* of tobacco—something that Columbus had introduced to Europe some 400 years before—only started to become popular at about this time with the English middle classes.^

Part of the reason for this long delay in the development of the smoking habit may have been the attitude of the British royal family toward tobacco. James I, it seems, abhorred tobacco. The fact that it was a principal product of his new colonies in the Western Hemisphere did not seem to have a bearing on his thinking. In fact, his words would make modern anti-smoking advocates envious:

> A custom loathsome to the eye, hateful to the nose, harmeful
> to the braine, dangerous to the lungs...

The royal attitude toward tobacco hadn't changed much by the time of Queen Victoria's accession to the throne. Once she reprimanded an aide for having smoked while decoding a series of telegrams from her representatives abroad: the dispatch box, she said, reeked of tobacco odors. Despite the Queen's attitude, her son—the future King Edward VII—was thoroughly taken by tobacco. He was apparently so addicted, in fact, that he encouraged membership in one particular London club—significantly called The Marlborough—because it decided to permit smoking throughout *all* of its rooms.

Ironically, the burgeoning use of smoking tobacco, came about as a result of the Great Exhibition. That event was the singular most important triumph of Queen Victoria's husband and something of which she was enormously proud. It seems that at the time of the Great Exhibition, smoking in public was acceptable on the Continent but not in England. Many Europeans who traveled to London to see the exhibits thought it no breech of etiquette to smoke whenever they felt the desire and wherever they happened to find themselves.

The English at the time, watching their foreign guests lighting their pipes and cigars in public, were apparently reluctant to say anything to them. (Signs indicating where smoking was and was not permitted would come much later.) One presumes that while the women may have been offended, the British men—many of whom themselves were addicted to tobacco— were probably envious. Rather than speak to the foreigners on behalf of the ladies, the men simply decided to join them. As a result, smoking gained enormous popularity as the practice emerged from the drawing rooms to the public rooms. While many products connected to tobacco were made of ivory, cigarette cases are not prevalent among them. The reason is that

cigarette cases are generally made to hold *machine-made* cigarettes. It was not until after World War I that the value of the sales of machine-made cigarettes exceeded that of loose tobacco.^

By then, the use of ivory as a material for male accessories had slackened considerably. As noted before, interest in billiards had faded, and the importation of tusks for the manufacture of balls had dropped. Moreover, the new plastics—on their own or combined with leather, shells, cloth, or other materials—were offering artisans many new opportunities to demonstrate their talents and increase their profits. Both boxes and cases to hold manufactured cigarettes were being crafted from plastic.

Tobacco, of course, had not always been so complicated a habit involving so much paraphernalia and so many social concerns. Originally, it was either inhaled as snuff or smoked in a pipe by a wealthy few. In fact, tobacco *graters*—used to grind the plugs of tobacco into snuff—are one of the few functional items discussed in most books devoted to ivory as an art form.

Beau Brummell was said to have owned 365 snuff boxes—one for each day

1	Chinese snuff bottle
2	Bucket for pipe cleaners
3	Hinged-top snuff box
4	Pocket match box
5	Cigarette holder
6	Cigar cutter
7	Table top match holder
8	Cigarette case

of the year. Here was a man who dedicated his entire life to the problem of consuming leisure time. He is even said to have perfected a technique that permitted him to open his snuff boxes one-handed (with his left). For the less dextrous dandies of the day—who perhaps wanted to demonstrate an equal amount of male macho—snuff boxes made with little hinges and thumb nail tabs soon appeared. (*See photograph, p. 82.*)

While Brummell had an enormous influence on style, fashion, and manners, he was also described as corrupt, venal, and selfish. After loudly pronouncing to a London importer that a new shipment of tobacco from Virginia was insufferably bad, he allowed the devastated man to give him a generous supply from "deeper" in the barrel "to re-test." Soon afterwards, Brummell permitted word to spread that he was now using and enjoying the new shipment. As a result, sales boomed. ^

If only men tended to have ivory accessories associated with tobacco, both sexes found themselves carrying *vinaigrettes* in pockets and handbags. These devices were a defense against the smells common to urban streets in the days of horse-drawn transportation and before universal private bathing.

> A vinaigrette is a tiny, pocket-sized box with holes punched in its case. The top of the vinaigrette is removable to insert cotton soaked in perfume. Thus, the pleasant odor emanating from the vinaigrette, when held close to the nostrils, was intended to overwhelm the more offensive odors of the street.

To make the point about odors of the day, Charles Lamb, the Victorian historian, described Hyde Park after a public celebration in the following way:

> *...the stench in liquors, bad tobacco, dirty people, and provisions conquers the air and we are stifled and suffocated.*

Most vinaigrettes were made of gold or silver. Since the people who were part of the problem could not afford either a gold or silver vinaigrette, it is unlikely that they would have had one made from another costly material. It is probable then that ivory vinaigrettes expressed an aesthetic preference, rather than some class or economic difference.

The vinaigrette in my collection is ivory and it is in the shape of a globe. It is even decorated with lines of longitude and latitude etched into it.

Each hemisphere has a different number of holes to allow the perfume to emerge and the holes are unevenly spaced. I suspect that both the shaping and etching of this globe were done by a master craftsman, but that the sloppy workmanship of the holes may have resulted from leaving the drilling chores to an apprentice.

Here again is another intriguing mystery of the collection:

- Did the craftsmen involved even notice this detail?

- Was this particular vinaigrette ever sold to a customer or did it find its way to market as the 19th century equivalent of a manufacturer's second?

- Or could it be possible that the buyer simply didn't care about the configuration of the holes and was satisfied with just having something different—a vinaigrette made from ivory, rather than from gold or silver?

While several accessories made in the 19th century are used today in their modern form—most tobacco items, for example—some are not: *button hooks* and *glove stretchers* come immediately to mind as two necessities of days past that have no real function as we approach the 21st century.

- I have a pocket button hook in my collection. *(See photograph, page 76.)* It was carried by ladies in their handbags. Formal gloves in those days tended to be long, and most had buttons that had to be fastened with a circular hook. It was a relatively simple matter, apparently, to do one glove completely up with a free hand, but it became a difficult matter to do up the other with a by then gloved

hand. At home, a lady would likely have the assistance of a maid or a relative for this chore. But in public she would be on her own—particularly if she had to remove a glove to repair her makeup or go to the toilet. The pocket, fold-up button hook, designed to be carried in the handbag, must have been a very popular item when it first appeared.

• Glove stretchers were also used to help get a lady's gloves on. *(See photograph, page 76.)* These devices were inserted into each of the fingers of leather gloves, one at a time, to expand them before pulling the gloves over the hand. The stretchers consisted of two long, tapered, and slightly concave pieces held together by a pin and spring mechanism. When the two handles of the stretcher were squeezed together, the opposite ends moved outwards to expand the leather. Glove stretchers were made from all kinds of materials. Many were made from wood, bone, or ivory. Wooden ones were often complimentary and given away when a new pair of gloves was purchased. This is not dissimilar from the present day practice of shoe stores giving free plastic shoehorns with the purchase of a new pair of shoes.

Bone and ivory stretchers, however, were personal items popular with middle class women. Both the bone and ivory used in each prong were always perfectly smooth; the handles were not. A few have wondrously elaborate carvings on the handles and some include silver at the fulcrum point where the two prongs are joined.

Glove stretchers somehow seem to embody much of the Victorian age itself. Because of their entirely functional and mechanical nature, they would seem not to have been gift items from men to women; rather women probably bought the stretchers for themselves or received a pair at some point from a female relative. Most glove stretchers were plain because they never left the dressing room drawer and would not be seen by anyone other than the owner, a maid, or perhaps a close relative.

This streak of practicality, at least in items never seen in public, is a facet of life associated with some classes during the Victorian era. It also probably explains why so many plain glove stretchers were made of ivory. They would tend to last longer. While bone could become brittle and break under the stress of forceful usage, ivory was not likely to do so. No one, of course,

eemed to consider the possibility that styles and fashion might change—
nding leather gloves as an everyday item of dress—before the ivory in the
tretchers would wear out.

Although glove stretchers are no longer a necessity, they are an example of
a Victorian item that has been recycled into a modern useage. I was selling
ome of the duplicates in my collection at a swap meet one weekend when
a young man began investigating a pair of glove stretchers I had on display.
As he bought them he told me that they would be put to another use. He saw
hem as an elegant "roach clip" for a friend—the device to hold and pass a
marijuana cigarette from one person to another to avoid burning the fingers
as the cigarette burns down. An ivory glove stretcher, it seems, made a
perfect Christmas present for someone into pot.

Jewelry

A distinguished Swedish jeweler, Sigurd Persson, has succinctly stated the
fascination of personal decoration since time immemorial:

> *Jewellery is a means of making one's individuality visible.*

Prior to Victorian times, ivory was infrequently seen in jewelry items—
except in royal collections. Yet with the exploding supply of tusks and
resulting scrap material available, ivory soon became a popular element in
the creation of new jewelry.^ Necklaces, bracelets, bangles, brooches,
rings, and earrings of every size, style, and shape were made from or with
ivory—much in the way that modern jewelry is fashioned from a wide
variety of materials and is created in a huge assortment of designs.

I have many ivory jewelry pieces in my collection. I do not, however, yet
have a *hatpin* with an ivory top. Hatpins, according to one of the leading
authorities on these imminently collectible items, have an important place
in Victorian history. Hatpins...

> *...enabled women to discard the bonnet (and apron strings)
> and adopt the masculine attire—a hat—as their symbol of
> equality.*

The creation of a machine to make pins in 1832 ended their relatively high
cost and also ended the need for women to save "pin money." The machine

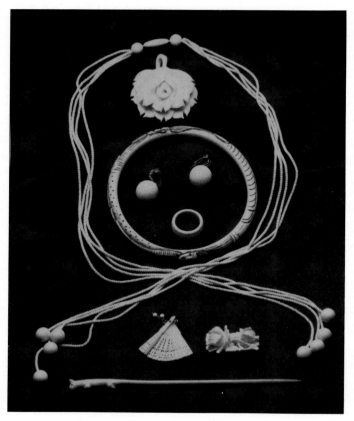

also increased the supply sufficiently to enable women to use them to hold a hat securely on their heads. Later, men would feign fright at what damage a 7-inch (about 18 cm) hatpin might do in the hands of an affronted or angry woman.

Once the novelty of women wearing hats secured by long steel pins had subsided, attention to decorating both increased. Practically every kind of jewel and form of decoration can be found on the tops of hatpins. For 75 years, such names as Carl Fabergé, René Lalique, and Tiffany Studio, as well as many lesser artisans, were involved in the making and decorating of hatpins.

Except for a few scrimshaw engravings and a few unusual examples displayed in specialty collections, ivory tops on hatpins are not particularly common. The reason that relatively few ivory hatpins can be found today is not entirely clear. I surmise, however, that ivory-topped hatpins may not

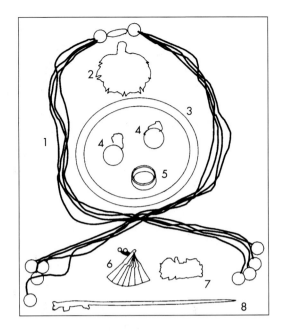

1 Walrus
 ivory tassel
 necklace
2 Rose
 pendant
3 Slave
 bracelet
4 Earrings
5 Wedding
 ring
6 Fan brooch
7 Rose stem
 brooch
8 African
 scalp pick

have been as popular as other materials because of the number of stick pins and other ivory accessories associated with *men's* shirts and ties. Ivory scarf rings, collar bars, shirt studs, cuff links, and more abounded at the time. *(See photograph, page 45.)* It could be that ivory, as a material became associated in the public's mind with male attire. As such, it was not thought of by women as something feminine enough for their hats—which were themselves essentially male makeovers.

In matters of clothing fashion, it seems that once a particular item of dress, element of design, or pattern of use becomes associated with one of the two sexes, the other sex tends to avoid it until there is some statement to be made in defying that tradition. The *walking stick* is just one of many examples of this phenomenon. ^

Walking sticks were adopted by males as the wearing of swords fell from favor in the early 1700s. It was as if men needed something to lean on, bang against, or hang on to lest they feel undressed in public. Fifty years later, women also began carrying walking sticks. But a woman's stick did not arise out of a missing sword. It was more in emulation of Marie Antoinette of France. Her willingness to defy fashion convention and carry what amounted to an urbanized version of a shepherd's staff—to popularize her

belief in a return to nature—permitted women everywhere to experimen with this new accessory.

Women's sticks soon became very feminine, with perfume dispensers an manicure sets sometimes hidden in their handles. Eventually, women' walking sticks evolved into parasols. Men's sticks, meanwhile, becam more and more elegant, with elaborately carved handles and hidden device as well—from swords to even violins.

Both the parasol and the walking stick, however, disappeared with th arrival of the motor car. It is probable that both sexes found these accessorie to be unnecessary and cumbersome—cars had roofs to shade ladies from th sun and were, in and of themselves, a more dramatic symbol of a man' power than either a sword or a **walking stick.**

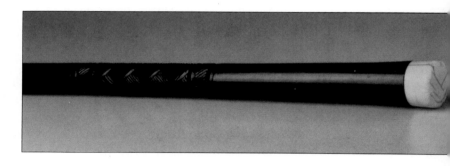

The same conclusion about particularized fashions for men and women ca be drawn about rings. Just as hatpins for women made with ivory decoratio do not seem as common as ivory-decorated stick pins for men, so men' rings made from or with ivory seem to be rare when compared to the numbe of polished stones used in rings for males.

Yet women's rings carved from ivory are commonplace in every shape an design. Otello in Verdi's opera presents such a ring to Desdemona as special token of his love. In fact, very few ivory rings for men ever come t market. I even suspect that some of those ivory rings now identified as man's ring were originally made for a woman with very large hands. Ivory in rings probably became solidly associated with female fashion accessories A man's ring made out of ivory no doubt seemed at the time too effeminat for most men.

oilette Articles

Most women's toilette articles, it appears, were created with public display in mind. Elaborate combs, mirrors, compacts, nail files, polishing brushes—made from or embellished with ivory—were widely available.

My favorite woman's toilette article looks like a squat mushroom; a round, bulging top sitting on a small narrow stump. *(See photograph, page 76.)*

When I bought this particular piece in England, neither I nor the seller knew exactly what it was. Indeed, the seller suggested to me that it had probably been a bottle stopper. I didn't have a better idea at the time, but I liked the shape and was taken with the high quality of the ivory used by the maker.

On the flight back to Los Angeles, I kept the piece in my briefcase. It apparently got a good bouncing around. When I unwrapped it at home, the top seemed loose as if it had cracked. After a little inspection and some pushing and pulling, the top came completely off to reveal a base still partially filled with a solid, rose-colored rouge material.

What a lovely, exciting discovery. A miscellaneous "bottle stopper" was in fact a mushroom-shaped compact. As such, it was a lot more valuable than the price I had paid.

If women's toilette articles for the most part were intended for display in a dressing room, most men's toilette articles seem as if they were intended for travel only. Moreover, the material used to make or decorate men's toilette articles seems to have been more horn and antler than ivory. I suspect that the use of horn and antler for these items was popular as a reminder of local hunts and the trophies that can come from them.

Nevertheless, some lovely and interesting ivory pieces can still be discovered in this category. My own collection includes:

- An ivory-handled boot jack. *(See photograph, p. 96.)*
- An ivory-handled razor strop. *(See photograph, p. 96.)*

- Ivory-backed mirrors. *(See photograph, p. 77.)*
- An ivory-backed nail file and orange stick. (Not photographed.)

Most prevalent among the men's toilette articles, however, are the various kinds of brushes—for the hair, for the beard, for nails, for teeth, for clothes, for crumbs, and more. For some reason, though, bone rather than ivory or horn, was favored for the handles of straight razors. This lack of ivory-backed

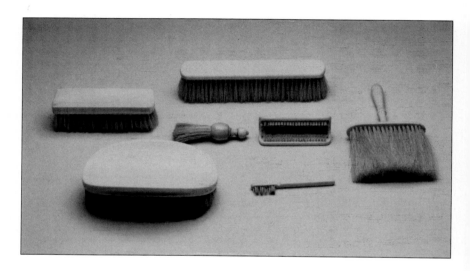

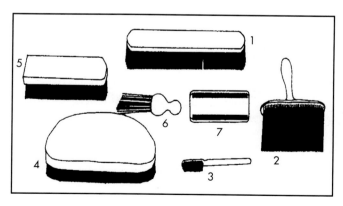

1	Gentlemen's clothes brush
2	Whisk broom
3	Tooth brush
4	Hair brush
5	Ladies' clothes brush
6	Shaving brush
7	Nail brush

razors is all the more surprising because ivory survives better than bone when constantly immersed in water.

It strikes me that bone, rather than ivory, may have been favored for straight razors as a matter of practical economics. The steel blades of these razors were prone to rusting, microscopic chipping, and other damage. Once so marred, the blades would have been dangerous for shaving and would have felt different after regrinding. As a result, razors encased in bone would have been much cheaper to acquire and could be more easily discarded than those that would have been made from ivory. While new blades could have been inserted in ivory handles, it probably would have priced these razors outside the reach of the emerging middle class.^

Perhaps the most prevalent male item made with ivory is the pocket knife. They were made in both large and small sizes, with both single and double blades, to suit any purpose—from cutting lumps of tobacco to separating the pages of a book.

My personal favorite, however, is a tiny knife and fork all encased in an ivory jacket no larger than 2-1/4 inches (5.7 cm) long. (*See photograph, page 96.*) While it wasn't a substitute for normal cutlery, it does show Victorian sensibility for using the proper implement for every type of food or occasion—even when fingers might do.

Many items made from or embellished with ivory were considered personal accessories at the time they were made. Today we see them more in terms of their functional use. Those items are discussed in the next chapter.

OTHER USES OF IVORY

As noted before, ivory has been used through history for a variety of personal, decorative, and religious objects—but prior to the Victorian era by only a fairly select few and for only a fairly small number of items. With the rising popularity of billiards and piano playing, however, ivory was suddenly in heavy demand. Victorian men and women were pursuing their newly acquired leisure time with the help of their new wealth and with their usual dedication to doing it "properly."

Entertaining also expanded. Ivory was soon a popular material to add to table decorations. The creation of piano keys and tableware items— themselves made from the discarded portions of tusks unsuitable for billiard balls—still left huge amounts of scrap ivory to be used for other things.

In the previous chapter we looked at the personal uses of ivory in the accessories that men and women carried, in the jewelry they wore, and in the toilette articles they used in their homes and during travel. This chapter is devoted to the use of ivory for *non-personal* items.

Business Equipment and Sewing Implements

During the last quarter of the 19th century, the solid ends of African elephant tusks—the sought-after material for the manufacture of billiard balls—were priced in the Antwerp market at about $3.50 per pound (450 g). The hollow portions of these same tusks sold for about $2.50 per pound. The tips from the solid end—the only part of the tusk with an enamel coating and very difficult to work with—were priced at $1.

Yet even these tips were put to use—as harness trimmings. Ivory added color and elegance to the places where bits, bridle, and reins were brought together. Like many other things made with ivory, celluloid and other plastics eventually replaced even harness trimmings.

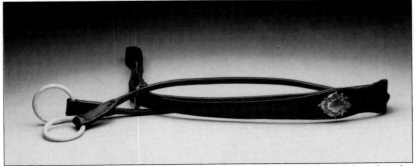

Called a martingate, this device is designed to restrain a horse's head from striking the rider. Like other tack equipment, it is beautifully appointed with ivory and silver mountings.

When it came to ivory embellishing the everyday equipment of *business*, there seems no end to the number of different items. For example, I have in my collection singular or multiple examples of:

- Pens
- Pencils
- Pistols^
- Rulers
- Inkwells
- Document seals
- Note pads
- Card cases
- Portfolio cases
- Paper knives
- Paperweights
- Desk-top magnifying glasses
- Pocket-sized magnifying glasses
- Quill cutters
- Blotters
- Chalk shakers
- Drafting tools
- Medical instruments

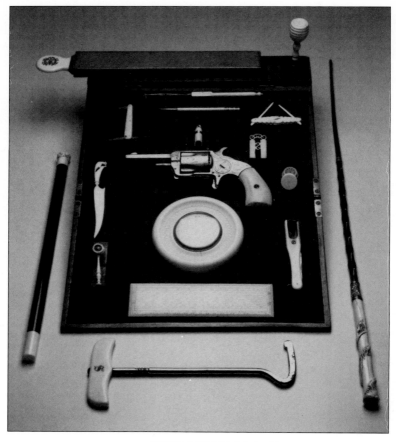

1	Razor strop
2	Document seal
3	Riding Crop
4	Boot jack
5	Marshall's baton
6	Drafting Pencil
7	Ear pick
8	Chalk shaker
9	Quill cutter
10	Ruler
11	Field microscope
12	Letter opener
13	Field knife and fork
14	Drafting pen
15	Chinese chop
16	Desk clock
17	Pistol
18	Dog whistle

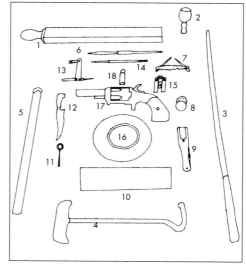

Making or decorating sewing implements with ivory also seemed to have been very popular with the middle classes. Among the *sewing implements* in my collection are:

1 Crochet hooks
2 A thread spool
3 A pin case
4 A bobbin
5 A ribbon needle
6 A weaving guide
7 A tape measure

There are two particular pieces in these categories—one for a man's business and the other for a woman's sewing room—that are worth describing in some detail. Both tell us something about what was important to Victorians.

- A tiny **ivory gavel** looks as if it were a presentation gift to the retiring chairman of a charitable society or for use by an association of little people. It is not. The clue to the use of this piece is its hollow handle, which hides a mechanical pencil. The pencil emerges from the handle whenever a little lever is pushed forward. The gavel was

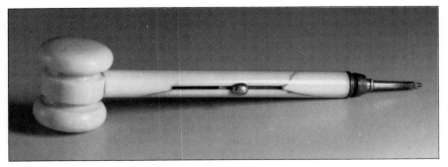

actually made for and used by auctioneers. The barrel portion, when rapped on a desk, started and ended the bidding. The gavel was then turned around so that the handle could be used as a pencil to note the final price and identification of the bidder.

- A tiny ivory **container** looks like a miniature knife box with its distinctive sloping lid. It is as if it were made for the sideboard in the dining room of the wealthy occupants of a doll house. Most real-size knife boxes were actually made of mahogany and decorated with veneers, inlays, and some metal. As noted before, the boxes were sloped to show each individual knife handle when the lid was raised and to prevent the blades of the knives from touching and chipping. The little ivory box, however, was obviously meant for display in a sewing room. When its lid is opened, it reveals a precisely fitted pewter thimble.

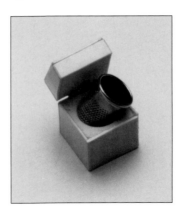

Pewter, of course, is a tin alloy (mixed with copper, lead, or brass) and not a precious material. Why would an ivory container, shaped like a knife box, be made to house a pewter thimble? Pewter thimbles, in themselves, are rare. It could be that this thimble was originally given its ivory home because of its intrinsic value or because of some sentimental reason having to do with its previous owner.

It may also be that a far less romantic reason is involved. The original buyer simply wanted a nice gift and chose an ivory box with a pewter thimble—like we might choose a gold watch with a leather strap—because the giver couldn't afford either a gold or silver thimble to go with an elegant box.

There is another possibility. So many of the most interesting ivory items in

my collection seem to have been fashioned from pieces of ivory scrap. This box is literally thin slabs of ivory cut and glued together. Perhaps the size and shape of this box had no deeper meaning than something that could be fashioned together from the available bits of ivory left around an artisan's workroom. Its sloping knife box shape may have no more importance than that it was the most suitable design for the size and shape of the scraps then available.

Household Artifacts

The household arts, in my terms, encompass all those *decorative* ivory items that were usually displayed in a room, on a table, or as part of another artistic work. These are generally the statuettes, busts, friezes, portraits, paintings, and models that have long been admired by art commentators.

In fact, these are the very items that have been extensively discussed in other books dealing with ivory. As discussed at the outset, most authors only treat ivory objects in terms of their aesthetic contribution or their overall historic place. They have tended to ignore a host of other everyday ivory objects that had an important place in the development of our culture. Ivory was often combined with other metals in household items. Tea and coffee services, for example, could be finely worked, ornate designs of silver or gold. Many of these sets came with ivory handles. *(See color photograph, p. 70.)* Here, the ivory served both a decorative and a functional purpose. The handles looked nice and they remained cool to the touch, even when boiling liquids had to be poured from the various pots.

During Victorian days, ivory also became a favored material for door knobs. Perhaps ivory was chosen to eliminate static electrical shocks common in winter with metal door knobs. Or perhaps ivory door knobs were simply easily fashioned from billiard balls rejected in their manufacturing process. Ivory was used in other parts of the house as well:

- One architectural object I have in my collection is another one of those mystery pieces—hard to guess what its original purpose may have been even though it is fairly easy to describe. It is an ivory whistle attached by a brass chain to what appears to be an ivory bell. The bell, however, has no clapper and no handle, just a hollow top with screw threads showing at thetop. It turns out that the bell-shaped portion of this piece acted as a miniature megaphone when

attached to a hollow tube in the wall of a Victorian home; the whistle, when blown, alerted the staff below to a need of the masters above. It is both attractive and functional.

Piccolo Wall trumpet

Electric switch

- Later, with the advent of electricity, the call downstairs to summon a servant became virtually effortless. But ivory was still used to decorate the electric switch.

- Ivory not only served as the favored material for piano keys, but it also found its way into woodwind instruments—such as piccolos and clarinets—in the form of mouthpieces. Ivory was also used to decorate various stringed instruments. Ivory can be found serving as the frets on the neck of a guitar, as the knobs on the pegs of a violin, and as the handle grip for a bow.

Games, Gifts, Toys, and Souvenirs

It is perhaps natural to close these various descriptions of different objects made from or embellished with ivory at about the same place where they began—with a discussion of how games involved ivory objects to enhance the pleasure of the players or demonstrate the wealth of the host.

Golfers, for example, took to having an ivory disk inserted into the heads of their drivers. These golfers had noticed the special resiliency of ivory when playing billiards. It was this resiliency that provided billiard balls with the added bounce as they caromed off each other. The golfers thought that a small lump of ivory might do the same thing for a golf ball—send it a greater distance when struck.

Besides billiards and golf, though, the bulk of other games using ivory objects involved gambling. Ivory was one of the favored materials used to make devices that helped keep score or settle financial accounts at a game's conclusion. Most counters came to Europe's royal, noble, and fashionable homes from China in the 18th century—along with tea, silk, furs, and rice. The finest of the counters were carved from mother-of-pearl in every geometric shape and incised with different symbols. Many of these counters were stored in beautifully turned and deeply carved ivory boxes.

European merchants residing in China in the 18th and 19th centuries apparently took to gambling games to occupy time between negotiating sessions with their Chinese suppliers and/or the need to supervise an incoming or outgoing shipment of goods. The counters they ordered to be used in these games were created by Chinese craftsmen employing the crests, coats of arms, or personal initials of the European merchants. ^

Game counters
and box

Miniature chess table
Ivory checker piece

It was not long before fine examples of these counter sets were being displayed in Europe. They contained round, square, oblong, and rectangular pieces—each shape representing a different numerical or monetary value. Other counters were carved in the form of flowers and birds—with two or three different sizes to differentiate values. The fish—a Chinese way of symbolizing human life and a Japanese symbol for perseverance—became one of the most popular form for counters. In fact, in *Pride and Prejudice*, Jane Austen has one character talking "incessantly of fish lost and fish won." This is an obvious reference to gambling with game counters.^

Ivory has also long been heavily employed in the making of chess pieces. Chess, of course, involves only 32 pieces: 16 are pawns and are usually carved in identical shapes and designs; each of the other 16 pieces is a duplicate of another piece. There is, in short, seemingly little room for originality. And yet, ivory chess pieces are some of the most fascinating miniatures to study. Exquisite in detail, humorous or serious in execution, they are each works of art in themselves.

Like chess pieces, ivory cribbage boards come in every imaginable shape and decorative pattern. *(See photograph, p. 22.)* Some lovely boards are made wholly of a solid piece of ivory, and others are merely embellished with ivory. In fact, solid ivory cribbage boards are one of the few uses for *whole* walrus tusks. Many cribbage boards were fashioned in India for sale to a British colonial—for use during his tour of duty and to have as a souvenir to take back home.

Other souvenirs made from ivory are also worth discussing:

- I have a miniature **cricket bat,** inlaid with tortoise shell flowers in a particularly lovely and delicate Japanese technique called *shimbui* (literally "a pleasing blend"). It was probably just the type of small

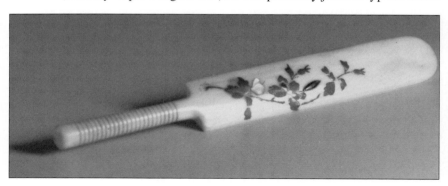

item sailors on leave liked to acquire to take home to England as a gift for a child or as a remembrance of a particular voyage.

Cricket, of course, did not exist in Japan until the British brought the equipment and the interest to play. A Japanese ivory carver could have decided to carve and decorate the toy bat for no better reason than he saw an opportunity to make a new item that would sell to a new customer base.

• I also have a miniature pair of binoculars as well as a telescope; they are actually souvenir viewers. Hold either to a light source and an incredibly small, but detailed, black and white photograph of a tourist attraction is revealed—temples, churches, and public buildings seemed very popular for these pictures. Viewers were apparently the main purpose of many other ivory souvenir items: needle cases, picture frames, pendants, etc.

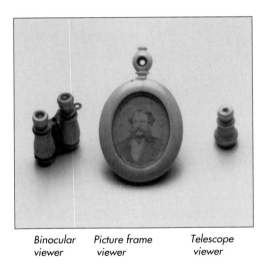

| Binocular | Picture frame | Telescope |
| viewer | viewer | viewer |

Over the years since they were originally sold, many of these viewers have lost their pictures or the lens that magnified them. I am always delighted when I find pieces with their tiny photographs still intact. But one time I didn't realize how delicate this feature of these souvenirs really is. In washing the piece in soap and water, I completely washed away the black and white miniature photograph. As a result, I probably reduced the current value of this piece by more than 50 percent. ^

Finally, no discussion of games employing ivory could be complete without a discussion of **dice**. Since long before Biblical times, two numbered cubes have been rattled together, flung against a barrier, or bounced on a flat surface. Gambling money on the random outcome of the numbers revealed on the top face of each cube has been a part of most cultures. Given the beating these two cubes tend to experience in the course of play, it would seem that the hard, dense nature of ivory would have made it an ideal substance for each die. But, in fact, relatively few pairs of ivory dice were made. Those that are on the market today tend to be smaller and were probably originally part of another game such as backgammon. Dice games themselves demand larger playing cubes.

I suspect bone, rather than ivory, was invariably used for dice games because bone was so much less expensive. The Bible reports that Roman soldiers were playing what is assumed to have been a game of dice ("...for my vesture...they did cast lots") even as Christ was being crucified. Because of this fact alone, it is not hard to appreciate the level of revulsion for the game in certain circles.

As a result, it is likely that only lower elements of society played the game of dice, and ivory dice would probably have been unaffordable. Cheating at the game itself could also have been a reason for using bone rather than ivory. Bone dice, because of their more porous core and more brittle nature, would have been easier to fill or shave than ivory cubes. Whatever the actual explanation for the rarity of ivory dice, the common expression among dice players is to throw "the bones." Their description is historically more accurate than most of the players probably know.

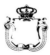

COLLECTING IVORY TODAY

Collections devoted solely to ivory as a material seem to be fairly rare. Most private ivory collections tend to be focused on particular *styles* or different *types* of objects made from or with ivory—18th century statuettes or netsuke animals, for example. Even in museums, ivory pieces are more likely to be displayed in connection with other related works of art or with particular historical periods, rather than amassed in any single place under a heading of *ivory*.

This is not surprising. The different uses of gold might be the subject of a special display at a museum from time to time, but it probably would not be the basis of any single collection. Collectors tend to narrow their interest in a material to something more specific than simply different examples of its uses. It seems that as most individuals get deeper into the details of their collections, their focus becomes clearer. It is not unusual to see someone progress from merely collecting *coins*, to an interest in *American coins*, to a specialty of *American gold coins*. The same progression is common with other collectibles. A person can move from a general interest in *bottles*, to *snuff bottles*, to a specialization in *jade snuff bottles* only.^

In narrowing their focus, serious collectors also try to improve the quality of the items in their collections. They begin to exchange one form of an item for other examples that are better made, rarer, or more historically or artistically significant. The tendency to limit the focus of most collections, I suspect, is caused by economic forces. Funds to acquire new pieces are either not available or space to display and store a collection is too expensive. The tendency to enhance the quality of a collection is also probably driven by a collector's growing understanding of the subject of his collection. That, of course, is the purpose of most serious collecting—to preserve examples of a body of material and to understand how the objects

THE FASCINATION OF IVORY

are related to a larger whole. While fine theory, it sounds as if collecting lacks passion. It doesn't. Here is my favorite example of how strongly collecting grips serious collectors:

> The world's best known netsuke collection was assembled by a Japanese-based, American lawyer named Raymond Bushnell. Over the years following World War II, Bushnell came to be in great demand by American corporations and individuals doing increasing business in Japan.
>
> Eventually, Bushnell got so busy that he took to sending staff members to attend less important conferences and to meet with those he perceived to be less important clients. As one writer has noted: "Savvy businesses soon learned that the way to get Ray Bushnell [himself] to a meeting was to buy an important netsuke or two and ask Bushnell if he had any interest in acquiring them." The believable truth is that Bushnell not only showed up for these meetings, he arrived *early* in order to have time to inspect the netsuke. ^

If daily newspapers have been described as the first draft of what later will become recorded history, then private collections can be described as the warehouses for the world's great museums. Collectors, in fact, are the first line of defense against the destruction of artifacts of the past. As historian and collector Lillian Baker has written:

> *So much of the past has been lost because there were few historians who lent enough importance to the simple items in common usage. Yet how [they]...rejoice upon discovery of these everyday 'tools' in excavations.*

Without private collections, museums would likely have little to show to the public; with them, museums have the privilege of culling the best of any type of artifact for display.^ Collections also allow a side-by-side, in person, visual comparison of objects that reveal certain details that books, photographs, and other documentation often miss.

In terms of ivory objects, there are many areas that deserve special attention from collectors. As always, any ivory objects used to depict historical or religious events are fascinating; ivory carvings exhibiting special qualities

of style, technique, or aesthetic value similarly ought to be preserved and when possible gathered in one place. In addition, we need to learn more about why ivory was used with other materials. For example, the *Encyclopedia of Antiques* notes:

> *Since Anglo-Saxon times, at least, the rare, the curious, and the valuable have been made precious and more beautiful by the addition of gold and silver mounts.*

If gold and silver enhanced ivory, as it did, why was ivory also used in certain combination with brass, tortoise shell, wood, and leather?

It would be nice, for example, to understand better why certain objects were made from or embellished with ivory and others were not. For example, ivory was heavily used in the design and manufacture of walking sticks, but was seldom made a part of the design of clocks or barometers. Are these matters of fashion or taste—or perhaps sheer happenstance—or could larger social issues have been involved? Are the answers to these questions more a matter of economics or of artistic preferences? Could they be more a matter of the supply of the material or the demand of the craftsmen's clientele?

In my view, the answers to these inquiries are probably of very modest historical significance. The real importance in understanding the use of ivory lies in protecting elephants from the extinction that has threatened them in the past. If we come to learn why people have been historically attracted to ivory, we may do a better job in the future in redirecting that interest or controlling it in other ways.

The Elephant

No discussion of the fascination of ivory can be complete without an understanding of its principal source of supply: elephants. While other animals, of course, grow tusks and provide ivory, no other species grows tusks to the size of elephants; and no other tusk-yielding species is as easily hunted as elephants. Knowing more about these animals—how and where they live and their relationship to man—is a cornerstone to understanding more about controlling the use of new ivory objects in the future.

To begin any discussion about this animal requires a few basic facts:

- The elephant is the largest land animal on earth. As noted before, it is found in both Africa and Asia, with the most distinguishing difference between the two species the size of their ears: African elephants have much smaller ears, set close to their heads.

- Elephants are vegetarians. Adult animals consume an average of two *tons* (about 2000 kg) of food and 450 gallons (approximately 1700 liters) of water each week. In the wild, securing its food supply is an elephant's daily concern. This fact alone also suggests why elephants and man are often found on a collision course. Elephants have no natural enemies other than man. In fact, man would probably not be considered an enemy had the elephant been sought to put meat on the table, rather than money in the bank. If man did not bother the elephant for his tusks or his turf, it is likely that only lack of a consistent food supply, caused by natural circumstances, would control the number of elephants.

- Elephants, in their constant search for food, tend to be enormously destructive as well as wasteful. They bring whole trees crashing down just to get a few berries near the top-most branches. This has caused considerable deforestation in parts of Africa, engendering the growth of grasslands and a change in rainfall patterns. As the elephant's natural food supply has disappeared and man has approached, some animals found that plundering man-made storage depots and planted grounds were an easier way to feed themselves. Both natural changes in the environment and man have reduced the elephant's range in Africa. For example, in 1925, elephants could be found in about 90 percent of East Africa; in 1950, they covered about 50 percent of the area. Today, they are confined to less than 20 percent.

- Elephants have a treasured place in literature and mythology. Buddha, for example, was said to have been born of an elephant. Elephants hold a special fascination for man because of their huge size and their simultaneous capacity for delicate movement. Elephants can be both brutal and gentle—enormously strong when they need to exert their power and extraordinarily compassionate when dealing with their young.

- But for all of these qualities, I suspect the elephant's *trunk* is what

has seized man's imagination: this organ has evolved as part nose and part upper lip. Although it acts as an arm for the animal, it has neither bones nor joints. Nevertheless, it has the capacity to smell, grip, lift, reach, store, sound, or throw both solids and liquids. Baby elephants have even been observed sucking their trunks much as human babies suck their thumbs. The trunk, then, clearly sets elephants apart. It gives them a facility few other creatures have.

An elephant's *tusks*, on the other hand, hold another kind of fascination for man. The fascination, I suspect, is in their shape and size. As an organ that never stops growing, larger elephants can develop perfectly enormous tusks. One such animal in Kenya—called Ahmed—had tusks so large for his body that they appeared to drag on the ground at the end of its life. But large tusks do not always seem to be biologically beneficial to the elephant. The greater the arc of a tusk, the more their use is inhibited. (The mammoth, a pre-historic form of elephant, is in fact often best distinguished by its circular-shaped tusks.) Shorter tusks with less curvature seem to be superior because elephants can better employ them for protection, for digging, for probing, for pushing, and for lifting. Large tusks have proven to be detrimental to elephants in another way: the larger the tusk, the more impressive the trophy to the hunter, either for display or for sale. (As noted before, tusks are sold at the first instance according to their weight.)

With most African tribes, the tusks of the elephant were treated in a special way. For example, they were often appropriated by royalty for their personal use. In one case, a chief was found to be using tusks as a picket fence around his property. In other cases, whole tusks would be mounted as decorative pieces in front of doorways or inside a hut. The very earliest ivory carvings were probably some kind of tribal record that a chief wanted to preserve. These were made with stone tools scratched on the surface of the tusk. Later, other tools were developed that could create the kind of relief carvings we are familiar with in today's ivory works. (*See photograph, p. 29.*)

It is probable that very few elephants, if any, were killed solely for their tusks before the 17th century. The Ivory Coast got its name during this era precisely because a profitable trade in tusks developed soon after the west coast of sub-Sahara Africa was regularly approached by sea. By the 18th century the trade had eliminated the elephants in the immediate coastal zone, though the name of the region remained.

The second explosion in ivory hunting came in the 19th century in the quest for suitable material to make billiard balls. The problem was that only quite specific size tusks would do—the tusks of young adult elephants. These tusks were relatively small and those of the female elephants more cylindrical—the kinds of tusks having a rounded, solid end with a slightly larger circumference than that of a manufactured ball. These kinds of tusks limited waste at the solid end. Since they were purchased by weight, the smaller tusks would also be proportionately cheaper. It turned out also that balls cut from the tusks of mature male elephants tended to be more beautiful, but some failed to roll true. If the nerve core was not located in the exact center of the manufactured ball, the roll would be uneven. Smaller tusks made the job of locating the nerve core at the center of the ball easier.

The requirement for these kinds of tusks caused the killing of younger adult elephants—those in their breeding prime. An elephant cow carries her young for nearly two years and nurses them for another two. With females breeding only once every four years, then, the number of young calves in a herd is relatively few. As more of these breeders were killed for the prime size of their tusks, the size of the herds themselves began to plunge sharply.

Conservation^

Many *societal* programs have been tied to ivory and the elephant. As noted before, one of the earliest of these programs was an attempt by British missionaries to stop the ivory trade. It was not out of concern for elephants, however. The British reasoned that if ivory was not being bought, then the need for slaves to carry the tusks out of the jungle might disappear. And if the need for slaves was thus reduced, the wars fought to capture slaves would end.

Other efforts to save elephants and their ivory have had much less promise. Only the changing interests of the public seem to have had any real impact on the fortunes of the elephant. As described above, the slackening interest in billiards after World War I—and the rapid development of plastics as a substitute for ivory—combined to save the elephant herds in Africa from extinction at that time. Not only were fewer tusks needed to make billiard balls, but soon excess capacity in the production of plastics forced designers to look for other uses for this new synthetic material. It was found in the same place. Wherever ivory had been used in the past, plastic could now serve in

Elegant wedding favor combined a Bakelite case with a satin tassel to conceal a telescoping cigarette holder with ivory mouthpiece.

its stead—from piano keys to jewelry boxes.

But the lessons of this era—that changing public tastes govern the demand for ivory—were not learned by those interested in protecting the elephant. The use of ivory returned to fashion in the 1970s—this time principally in the form of jewelry. As usual, the reasons are not entirely clear. Some think that ivory was considered the most appropriate material for professional women to wear as they assumed wider career choices in a liberated work world. Ivory was not flashy, but certainly rich in quality and quietly feminine—an appropriate daytime accessory for a woman's business suit or blazer. Women, in short, could offer a stylized impression of a man in the work place without looking like one.

As the concept of ivory jewelry caught on, the demand for different items exploded. Soon millions of different brooches, pendants, stick pins, earrings, and bracelets began appearing in Western shops. Buyers assaulted workshops in India and the Far East for product. And it was hard to get. The world was now quite different from the days before World War I:

- For one thing, it was a much larger place—world population in the intervening 50 years had grown from about 1.7 billion people to nearly 4 billion.

- For another, the world was also a much richer place in total wealth. A higher percentage of people than ever before could afford luxury items. If fashion called for ladies to wear ivory jewelry during the

daytime, millions more could now afford to buy it. Moreover, the increasingly affluent Japanese could demand ivory handles for the signature seals they used to authenticate documents. They did.

Some simple calculations indicate the pressure on the elephant herds exerted by this fresh demand for ivory. If one assumes that only 5 percent of the world's female population wanted to acquire ivory jewelry and if one further assumes that a pair of earrings, a pendant, a necklace, a bracelet and perhaps a ring require about 16 ounces (450 g) of raw ivory, then at least 350,000 tusks would have to be acquired to satisfy just these demands. With elephant herds estimated at just about 1.3 million animals in 1980, the loss of 100,000 to 150,000 animals per year would soon end the species. It almost did. By 1986, elephants in Africa were estimated to number no more than 800,000.

To solve the problem, many Western governments—under enormous and effective pressure from conservationists in North American and Western European industrialized countries—adopted strict codes against the *importation* of finished ivory products. These governments assumed that legally ending the commercial demand for ivory in this way would stop the killing of the elephants. It didn't. Dealers moved to buy ivory products before they would no longer be available. These dealers assumed that as ivory products became scarcer from a government-induced prohibition, those who had an inventory on hand would make money so long as demand for ivory remained unaffected by the government action.

So the price of ivory started to go up in anticipation of *future* scarcity. As the prices moved higher, poachers were willing to take more and more risks to earn the rewards involved. It soon turned out that the laws of economics were stronger than the laws of conservation. The elephant was in greater danger with the new international rules in effect than it had been before they were adopted. So in 1985, the world's interested governments used CITES— the Convention on International Trade and Endangered Species^ —to *regulate* the sale of ivory. The governments reasoned that it might be far better to try to control the *price* of ivory than to continue trying to enforce a total *ban* on its sale. As a result, CITES set verifiable limits on the amount of ivory a government could export—and the amount of ivory a government would be allowed to import. At that stage, CITES seemed to be a good start in limiting the amount of new ivory in world trade.

But since it only dealt with raw tusks and tusks being exported from country

to country, it did not control or count tusks retained within a country's borders. As a result, more carving shifted to Africa. More importantly, CITES didn't deal with *consumer* demand for finished ivory products which continued unabated. On the other hand, CITES did provide a source of money from the legal sale of elephant tusks—tusks generally taken from elephants living on reservations or game preserves—for tourism promotion as well as for conservation work and research.

These contradictions set the stage for a 1989 meeting of CITES members. Ninety-one nations agreed in Lausanne to place African elephants on the endangered list—a designation requiring a halt to *all* trade in ivory. An exception was made for four southern African states where elephants have been successfully protected with CITES funds—elephants representing about one-tenth of the number in Africa now believed to total about 600,000. The driving force behind the shift were conservation groups—such as International Union for Conservation of Nature, the World Wildlife Foundation, Friends of Animals, and the Humane Society of the United States. These groups ran a series of haunting ads in consumer publications and encouraged the showing of emotional television programs dealing with the overall shrinking elephant population. In the long run, their effort to cast new ivory items as an arrogant and shameful waste will probably be more effective in protecting elephants than the *legal* ban on ivory imports they fought so hard to impose on the United States, the European community, and Japan. Still the argument over elephants and the ivory trade is clearly not over.

Some 67 nations do not belong to CITES. The nations that do and that successfully protect their elephant herds have taken exception to the general trade ban and continue to sell tusks. Now the first warnings are being sounded that walruses—whose ivory is legal for working by Eskimo carvers only—are being threatened by excessive killings in the search for substitutes to elephant ivory. It is not that the world is anywhere close to being short of ivory—a minimum two-year supply is said to be now in storage in Hong Kong alone, and the trade from the CITES exception states will assure that new legal ivory will come to market. In addition, the bone of the water buffalo, a hitherto unknown and nearly unlimited substance for the carving trade, has great promise in terms of its finished appearance as an ivory substitute for accessories. Finally, the recycling of older objects made from or with ivory—such as the lovely globe on the cover of this book—should be specifically encouraged through better understanding of ivory as a substance.

But it is for the great conservation groups in the world's richest countries, having achieved most of what they wanted in Lausanne, to link with fashion designers, feminist groups, and cultural leaders to create an atmosphere that encourages the market to accept other forms of natural white material. Only then will the public demand for elephant ivory decline. Collectors can help in this process. They, among many, want to help preserve an important and beautiful material for artistic and decorative expression. As has been demonstrated, ivory can carry its message thousands of years into the future just as it has brought us important learning from generations past. Collectors should avoid all mass produced goods and insist on certificates of origin on the ivory of the newly carved objects they do acquire. If an ivory dealer doesn't know the carver, the age of the carving, or the origin of the ivory, the moral response today is to avoid purchasing the piece.

In short, if we all do our part in a responsible way, the elephant will be protected and the world will continue to have a unique source for beautiful objects into the future.

SOME CONCLUDING THOUGHTS

The first chapter of this book discussed how I was introduced to ivory objects as a young boy. Over the years, my attraction to this substance and the finished products on which it is used has grown.

While ivory has been employed to make or embellish practically every kind of product imaginable, I seemed drawn to those items where ivory was employed in much the same way as we might use plastic material today. When I purchased many of these items, I didn't realize that they were made from what had become essentially a scrap material. Later, I would come to learn that the relationship between plastics and ivory was much closer than mere cosmetics—that they bore an important functional economic relationship to each other. Thinking of ivory as if it were an historic form of plastic—as I once did—would soon yield to a more accurate conclusion that plastics were developed to be a substitute for ivory.

Ivory tennis racket charm appears in a plastic presentation case.

Plastic as a substitute for ivory continues today. The phone on my desk, as I write this has a plastic case. The case is low profile, modern, and sleek in design. The color of the case is ivory white. It does not seem strange, then, to hear that when Alexander Graham Bell was trying to interest Europeans in his new invention that he is said to have had an ivory instrument made for presentation to Queen Victoria. While everything we know about the history and uses of ivory suggests that this story could well be true, Buckingham Palace has no actual evidence of the Queen's having used such an instrument. ^

That ivory and plastic are so inextricably linked—despite the vast disparities in how we consider these two materials—seems proper. We often divide all things into animal, vegetable, or mineral worlds. In fact, the popular old television quiz show—*20 Questions*—only gave one hint about an object to be identified by the celebrity contestants. The host always indicated whether the object was animal, vegetable, or mineral.

Dr. Joseph Bakelund, the creator of the first totally synthetic plastic, came to refer to the creation of a Fourth Kingdom—the Kingdom of Synthetics. ^ Ivory actually has a place in all four kingdoms:

- It is a natural product of the *animal* kingdom;
- It has a substitute in name and color in the *vegetable* kingdom;
- It is carved and worked as if it were part of the *mineral* kingdom; and
- It is the basis for the creation of the *synthetic* kingdom.

In fact, the linkage between natural ivory and plastics has a special meaning for me. My father inspired me to enjoy lovely objects—and taught me about ivory ones. The fact that his principal business involved the recycling of scrap plastic—and that the proceeds from that business enabled me to go to university and begin earning enough money to start a collection myself—is a connection that did not become clear until I was well into completing this book.

It is also an appropriate thought on which to end it.

APPENDIX:
PRICING IVORY

Understanding the pricing pattern of items made from or with ivory is of continuing interest to dealers and collectors alike. As with all other commodities, of course, pricing starts with supply and demand. Because demand for ivory sculpture and scrimshaw among antique dealers and specialized collectors remains strong, prices of these items remain relatively high. In addition, canes, sewing implements, fans, and other collectibles made with ivory tend to be more expensive because of the competition for these types of items. Since most are also antiques, there seems no reason for interest to weaken except in reaction to a major general economic downturn.

Demand for *new* ivory objects, on the other hand, has already slackened in the face of publicly expressed, worldwide concern for the survival of elephants and walruses. By the same token, however, the supply of new items—those already carved or turned from tusks there were on hand before the ban was implemented in 1990—is not expected to diminish for at least three years. As a result, prices of most new items—particularly jewelry pieces and modern netsuke—will probably be soft for a few years to come.

Older ivory objects seem to follow a consistent supply pattern. They tend to come to market in great quantity in the spring and early summer—as attics are cleared, inheritances are reviewed, collections are broken up, and part time dealers reappear at outdoor markets. In fact, nearly all ivory comes to market through dealers rather than as transactions between collectors or in auctions. Since most dealers don't habitually trade in ivory items—and therefore may not be familiar with pieces in particular demand or with some intrinsic value of their own—they simply add anywhere from 15 to 25 percent to the price they paid for an object when reselling it.

If an object passes through at least three dealers before being seen by a collector—the normal turnover when items first come to market—then the price of any given piece can vary as much as 50 to 90 percent above a "base value." In short, the price paid for an item often depends on the point in the cycle that it is acquired. Because nearly all finished ivory objects reach the United States from abroad, pricing of individual items is also a function of exchange rates. In periods when the dollar has been strong against the yen, the pound, the franc, and the mark—as in the 1980s—ivory objects have been relatively inexpensive for Americans; in periods of a depressed dollar—the case at the outset of the 1990s—the opposite phenomenon holds true. Readers will do well to remember this potential wide range when considering the pricing of ivories.

With these caveats in mind though—and recognizing that very little ivory is actually purchased by weight alone—here is one way of determining price that may prove helpful to people new to understanding ivory:

- Relatively plain but solid ivory sells for around $100 to $150 per pound (450 g)—with the quality, color, grain, and condition of the material determinant of the final price.
- Carved ivory, depending particularly on the fineness and detail of the carving, is now selling in the $500 per pound area.
- Ivory in combination with silver has risen to around $800 per pound.
- Ivory in combination with gold—and depending, of course, on how much gold is involved—can be as high as $2,200 per pound in today's market.

People shopping for ivory items should realize that most dealers are willing to reconsider their marked or initially quoted prices. Ten percent is a usual opening reduction; if more comes off on the first cut, there may well be more yet to come. Here are some additional broad retail pricing rules for genuine elephant or walrus ivory today:

- Any piece selling in the United States for less than $15 should be treated with suspicion.
- Any piece selling for less than $35 may well be a bargain.
- Any piece priced under $75 is probably a good investment.
- Items priced between $100 and $400 deserve a degree of caution—they may be inflated by excessive dealer to dealer trades or other factors (including ignorance).
- Anything priced over $500 should only be acquired from a reputable dealer.
- Items priced over $1000 should be looked at by someone with experience in dealing with ivory.

Finally, because many of the items seen on the pages of this book can still be found in antique markets around the world, the following prices would be considered fair in the current environment:

- The ivory box (p. 10)—$35
- The ivory trowel (p. 20)—$135
- The ivory bud vase (p. 25)—$70
- The prisoner of war chair (p. 32)—$250
- The conductor's baton (p. 43)—$135
- The forks (p. 61)—$20 to $30 each
- The serving set (p. 63)—$200
- The teapot (p. 70)—$450
- The vinaigrette (p. 85)—$85
- The clothes brushes (p. 92)—an average of $20 to $35
- The auctioneer's gavel (p. 97)—$125
- The pair of dice (p. 104)—$40.

Having agreed to comment briefly on ivory pricing—the result of suggestions made by some who read early drafts of the book—I have the feeling that these comments may come back to haunt me as I continue the quest for additions to my own collection. Dealers may insist on comparable prices to the "fair" ones noted above, while I will naturally continue to try to obtain the lowest price possible. I look forward to discussing what has actually happened in succeeding editions of *The Fascination of Ivory*.

BIBLIOGRAPHICAL NOTES

Foreword

8 *"...many ivory objects..."* O. Bergbeder, *Ivory*, G. P. Putnam's Sons, 1965, p. 35.
There are literally libraries of books on every conceivable aspect of art, including the place of ivory as a medium of artistic expression. To understand the role of art in society, the author relied on John Ives Sewall, *A History of Western Art*, Henry Holt and Company, 1953.

The Special Appeal of Ivory

11 "O to be..." Robert Browning, "Home-Thoughts from Abroad," *The Oxford Book of English Verse*, 1957, p. 884.

12 Understanding silver hallmarks is not as easy as it would appear. With hallmarks in use for nearly 450 years—from cities in England, Scotland, Ireland, and elsewhere—and with thousands of makers to identify, the task can be as daunting as it is satisfying when a positive identification is made. There are many books on the subject. At home, I use Seymour B. Wyler, *The Book of Old Silver*, Crown Publishers, 1949, and on the road, Judith Banister, *English Silver Hall-Marks*, W. Foulsham & Co., Ltd., 1983.

14 Most antique ivory objects can be recycled to a modern use. The ivory casket, for example, served for years as a suitable place to keep dry fish food beside a tropical aquarium. See also bottom color photograph, p. 70.

16 James Draper, Curator of Decorative Arts of the Metropolitan Museum of Art, notes that their technical staff abhors the idea of "washing ivories" for fear of damaging them. They suggest using a moistened tooth brush to clean pieces. The Met's ivory collection is considered second only to that of the Victoria and Albert Museum in London. Other great western ivory collections can be seen in Munich, Berlin, and at the British Museum in London.

18 Alfred Harris, the author's father, entered the antique silver business primarily as a means of removing his capital from England just before World War II. While transferring *funds* at the time was difficult, trade in *products* was always encouraged. As a result, he started buying antique silver because it offered both an intrinsic value in its precious metal content and artistic value.

For other details on buying and selling used goods—whether antiques or not—see a book by the author and his wife, Barbara DeKovner-Mayer, entitled *From Trash to Treasure*, The Americas Group, 1985.

20 Senator Leland Stanford, when sealing the corner stone at the founding of Stanford University, pointedly rejected the use of a ceremonial silver trowel (perhaps thinking it too ostentatious and wasteful) in favor of a $1.50 mason's tool. This trowel, however, was properly inscribed for the historical record and has been preserved in the university's museum. See Karen Bartholomew, "The Design of a University," *Stanford Observer*, May 14, 1987.

23 The only other book that deals with ivory principally as a *material* is Benjamin Burack's, *Ivory and Its Uses*, Charles E. Tuttle Company, 1984. Although the book is somewhat hard to read and nearly devoid of analysis, its virtue is its attempt to offer an encyclopedic listing of objects made *from* ivory. It is inevitable that some have been missed. For example this line: "Ivory sandals have been mentioned in some writings, but this writer knows of none that may have survived." (p.109). Jonathan Mankowitz of Grays Mews, London, quoted the author a price of £550 (about $825 at the time) for the pair he

displayed in 1986. *Elephants and Ivories in South Asia*, a 1981 publication of the Los Angeles County Museum of Art, shows a picture of an elegant pair of sandals on page 87. More importantly, though, the Burack book only deals with objects made wholly from ivory, rather than with those objects made from other materials that incorporate ivory into their design.

Understanding Ivory

24 According to Bergbeder, *Ivory*, "most of the great cultures of the world have known and practiced the art of ivory carving...[in fact] objects made of ivory first appeared during the Aurignacian period, 20,000 years before our era." (p.7).

As if to demonstrate the continuing universal appeal of ivory, Mrs. Ronald Reagan announced in 1987 that she and the President had decided to acquire a two-foot (61 cm), carved ivory Madonna—originally presented to them by Pope John Paul II—as their Christmas present to each other. The statue was then valued by the General Services Administration at $800 and sold to them at that price. Even if one discounts the fact that this statue came from the Vatican's own collection and probably involved a high quality of carving, the sheer weight of an ivory object of this size makes the price suspect. (A similar piece is in the personal collection of the author's mother.) A two-foot statue consists of at least 15 pounds (6.8 kg) of ivory—at $125 per pound, someone wanted to curry favor with the Reagans. Despite some prodding from the author, the media did not touch the issue at the time.

For a small but comprehensive study of all aspects of ivory, see Geoffrey Willis, *Ivory*, Mayflower Handbook, 1970.

25 Ivan Sanderson speculates that ivory gained enormous popularity because of its importance as a religious symbol. He suggests that since the tooth is the least destructible part of an animal and retains power even after the rest of the animal is dead, the wearing of animal teeth necklaces—particularly necklaces made from ivory—is thought to transfer that power to the wearer. See "A Passion for Ivory," *Horizon*, 1960.

26 The English Bowling Association reported to Kenneth Katz, a colleague of the author and a bowls enthusiast, that while silver has occasionally been used for plaques on woods, no gold has even been seen. (Letter to author, January 29, 1987.)

28 The word "jade"—like "ivory"—has come to be associated with totally different concepts to their use as decorative items. Both were thought to have some special medicinal value (jade for colic; ivory for abdominal disorders) and both came to be used to refer to states of mind: a *jaded* person is someone bored or sated and one who lives in an *ivory tower* is thought to be unrealistic.

30 For a comprehensive and carefully constructed scientific discussion of ivory and other related materials, see Arthur M. MacGregor, *Bone, Antler, Ivory & Horn*, Croom, Helm, 1985.

32 For a discussion of diptyches and other forms of early diplomatic communications, see George A. Hearns, *The George A. Hearns Collection of Carved Ivories*, 1908 Catalog, p. iii. See also Paul Williamson, *Medieval Ivory Carvings*, Her Majesty's Stationery Office, 1982, for a look at ivories carved between 550 A.D. and 1050 A.D. See further, Carson I. A. Ritchie, *Ivory Carving*, A. S. Barnes Co., 1973, for a good discussion of prisoner-of-war work.

34 Scrimshaw (or skrimshander, as it was originally known) is discussed in depth in the following recent articles: Bonnie Schulman, "Scrimshaw," *Cape Code Home and Garden*, May/June 1990 and Laurel Kornhiser, "The Evolution of Scrimshaw," *Cape Cod Life*, August/ September 1989. The latter article features Thomas DeMont, the owner of Edgartown Scrimshaw, who sold the ivory globe pictured on the cover to the author.

35 Celluloid, first created in the United States, was followed by another plastic material

of similar composition in England. It was called "Xylonite." Both celluloid and Xylonite were thermoplastics—heated materials capable of holding new shapes once cooled. Newer plastics, such as polystyrene, polyethelene, and vinyl plastics are in this group. Bakelite and other similar earlier plastics were thermo-*setting* plastics: once shaped under heat they could not be reworked. See John Merriam, *Pioneering in Plastics,* published by East Anglican Magazine, 1976.

39 The comment, "At least the fakes..." was made by Alexander Schaffer, the proprietor of A La Vieille Russie—an elegant Fifth Avenue store in New York devoted to the art of the goldsmith and jeweler.

40 Alfred Marshall, in his seminal work, *Ivories,* reprinted by Charles E. Tuttle, 1966, notes the following about color in ivories "[some]...are entirely ebony, others resemble fossil wood...slate, sandstone and even opal...mammoth remains...become veritable turquoise" (p. 490). Another scholar (O. Bergbeder, *Ivory,* p. 31) claims that after time "Siamese ivory turns yellow, whereas ivory from West Africa...becomes whiter...[and] ivory from Ceylon turns a pale pink."

The Principal Uses of Ivory

47 "...sculptured ivories..." George A. Hearn, *Collection of Carved Ivories.,* p. vii.

See I. E. S. Edwards, *Tutankhamun: His Tomb and Its Treasures,* Metropolitan Museum of Art and Alfred A. Knoph, Inc., 1977. On the whole, I have found that African ivories tend to the more practical—jewelry, utensils—and always more playful in design themes than European ivories. See Kate Ezra, *African Ivories,* Metropolitan Museum of Art, 1984.

48 It is not well known that Agatha Christie did some of her best work while accompanying her husband, archeologist Max Mallowan, on digs in the Middle East. In fact, she had a hand in preserving some of the Nimrud ivories he uncovered. See Arthur Clark, "Mysteries and the Middle East," *Aramco Magazine,* July/August 1990. See also, Sir Max Mallowan, *The Nimrud Ivories,* A Colonnade Book, 1978.

Colleen McCullough's book, *First Man in Rome,* Morrow, 1990, describes the use of ivory in considerable and fascinating detail.

"one of the favorite..." Robert P. Pergman, *The Salerno Ivories,* Harvard University Press, 1980, p. 1.

"Lay craftsmen..." Joseph Nathanson, *Gothic Ivories of the 13th and 14th Centuries,* Alec Tiranti Ltd., 1951, p. 5.

49 See Massimo Cavia (translated by Raymond Rudorff), *Ivories of the West,* The Hamlyn Publishing Group Limited, 1970. In addition, O. Bergbeder (*Ivory,* p. 37) notes that "Etienne Bodeau's *Book of Trades...*" reports that in the year 1250 ivory was among the materials used by carvers and makers of images and crucifixes.

"...as the world..." *Encyclopedia of Antiques,* 1976, p. 310

50 "...no gentleman..." Stella Margetson, *Leisure and Pleasure in the Nineteenth Century,* Coward-McMann, Inc., 1969, p. 1.

For another interesting discussion tracing the reasons for the rise of leisure, see George Macaulay Trevelyan, *British History in the Nineteenth Century and After (1782-1919),* Longmans, Green and Co., 1956. There are many brilliant and interesting books that have charted the Victorian age in the United States and Europe. One of the studies we referred to was Allen Andrews, *Wonders of Victorian Engineering,* Jupiter, 1978. It should also be noted that while leisure brought the avalanche of ivory to Europe, King Leopold of Belgium gave prime tusks to artists to encourage carving in the hope that their efforts would *increase* ivory exports from his new colony, The Congo. It did. (Ritchie, *Ivory Carving,* p. 29)

54 Our discussion of billiards is based on ABC Sports, *The Complete Book of Sportsfacts,* Addison-Wesley Publishing Co., 1981; *Colliers Encyclopedia,* 1986; *Encyclopedia Britannica,*

1948; and Fred Kunz, *Ivory and the Elephant in Art, Archeology, and in Science,* Doubleday Page & Co., 1916.

55 For a full and interesting discussion of David Livingston and his meeting with Henry Stanley, see John Gunther, *Inside Africa,* Harper & Brothers, 1955. After discussions with Livingston, Stanley wrote about the high cost of ivory:

> *Every pound weight [of ivory] has cost the life of a man, woman, or child; for every five pounds a hut has been burned; for every two tusks, a whole village has been destroyed; every twenty tusks have been obtained at the price of a district with all its people, villages, and plantations.*

(Quoted in Ivan T. Sanderson, *Horizon,* pp. 90-91.)

56 See Sir Charles Petrie, *The Victorians,* David McKay Co., Inc., 1961, for an interesting discussion of the length to which fathers would sometimes go to help daughters acquire a husband.

"...those who study music..." *Family Living Magazine,* Winter, 1987.

The piano was created in the 1700s when an Italian, Bartolomeo Christofori, replaced the harpsichord's plucking devices with striking hammers. See the Metropolitan Museum of Art, *A History of Musical Instruments.*

"...put instrumental..." John Redfield, *Music: A Science and an Art,* Tudor Publishing Co., 1937.

"In the new suburban villas..." Stella Margetson, *Leisure and Pleasure,* p. 100.

"There were more pianos..." and "The American piano..." William Peirce Randel, *Centennial: American Life in 1876,* Chilton Book Company, 1969, p. 345.

58 Peter Friday's bottom line comment in *Victorian Architecture,* J. B. Lippincott Co., 1964, p. 78, on the Victorian era is interesting:

> *A countless number of new consumers was fed every moment with articles for which it had both the desire and the money to pay. The desire...was constantly whetted by an increase in the articles themselves, not of usefulness, but of ornament.*

59 For discussions of flatware, one of the more flagrant examples of Victorian excess, see Lewis D. Bement, *The Cutlery Story,* (publisher unknown) 1950, and J. B. Himsworth, *The Story of Cutlery: From Flint to Stainless Steel,* Ernest Benn (publication date unknown).

60 For complete illustrations (photographs as well as artists' renderings) of the variety of utensils used during the period—and to help identify the purposes of various spoons, forks, and knives acquired over the years—the author uses Marshall Field & Co.'s *1896 Jewelry and European Fashions Catalog.* Life has changed so much, in fact, that one mail order store recently offered a "three-in-one" *buffet* utensil—with curved bowl, short tines, and a serrated edge to obviate the need for a flatware set.

62 "[The Regent...], Stella Margetson, *Leisure and Pleasure,* p. 7.

Personal Uses of Ivory

74 "to be worn..." *Encyclopedia of Antiques,* p. 382.

75 "Ranging in height..." Scott Meredith, "To Love a Netsuke," *Parade Magazine,* May 4, 1986.

"the fables..." *Encyclopedia of Antiques,* p. 382.

76 For a book filled with lovely photographs and explanations, see Raymond Bushell, *The Wonderful World of Netsuke,* Charles E. Tuttle Company, 1979. See also Adrienne Barbanson, *Fables in Ivory: Japanese Netsuke and their Legends,* Charles E. Tuttle Company, 1961.

77 Valene Pakenham's *Out in the Noonday Sun: Edwardians in the Tropics,* Random House, 1985, chronicles the life of British colonialists in the years just before the First World

War. The book reports everything we have come to regard as part of the Victorian age. For example, the dust jacket for the book is illustrated by a picture of the British Governor of Uganda sitting among his hunting trophies and entirely encircled by two enormous elephant tusks being steadied by his bearers. For a wonderful review of the same period in the United States, see Walter Lord, *The Good Years: From 1900 to the First World War*, Harper & Brothers, 1960.

79 "...mark of good..." Stella Margetson, *Leisure and Pleasure*, p. 97.

Emily Post's *Etiquette*, Funk & Wagnalls Company,1945 edition, devotes fully 20 pages to "Visiting Cards and Their Uses." If there was any doubt about their social importance, note how the following (p. 78) might have rattled anyone trying to emulate Professor Henry Higgins's triumph in Pygmalion:

...if one has for the first time been invited to lunch or dinner with strangers, it is inexcusably rude not to leave a card upon them...unless one returns their hospitality with an invitation."

80 The "Language of the Fan" is adapted from Thelma Shull, *Victorian Antiques*, Charles E. Tuttle Co., Rutland, 1963, p. 407. The Shull book also has useful discussions of parasols, buttons, umbrellas, and other Victorian accessories.

81 Tobacco—first introduced to Europe by Christopher Columbus—was originally thought to *protect* users from disease. It may have. Tobacconists escaped the Great Plague in London in 1665, probably because the fleas that spread it disliked tobacco smoke. In the 1800s, *chewing* tobacco was considered a prime digestant. Smoking also inspired netsuke development in Japan. Tobacco had been introduced by the Portuguese, but the samurai never used it in public. Later when the merchant classes began their social accent, the tobacco pouch—with its attached netsuke—became a prerequisite for the successful merchant.

"A custom loathsome..." Quoted in Sir Charles Petrie, *The Victorians*, p. 181.

83 The height of tobacco's general acceptance began after World War I with the advent of readily available machine-made cigarettes. Its decline started with the Surgeon General's report on smoking and disease in 1964. By 1988, though, the *Wall St. Journal* could report that in just the previous five years smoking was "...increasingly seen as a character defect indicating weakness and lack of self-discipline."

84 For more stories about Brummel, see Stella Margetson, *Leisure and Pleasure*, p. 18.
"...the stench..." *Ibid.*, p. 7.

87 *"Jewellery is..."* Quoted in Ingrid Kuntzsch, *A History of Jewels and Jewellery*, St. Martin's Press, 1981, p. 9.

For a discussion of jewelry as a collector's item, see Lillian Baker's informative and well done *100 Years of Collectible Jewelry*, Collector Books, 1986.

"...enabled women..." From Lillian Baker's *Hatpins and Hatpin Holders*, Collector Books, 1983, p. 10.

89 The changing role of fashion is chronicled in many interesting books. For a brief but comprehensive review of the subject, see Agnes Allen, *The Story of Clothes*, Faber & Faber, 1955.

93 The author doubts whether David Brinkley in his book, *Washington Goes to War*, Ballentine Books, 1988, (P. 29) did more than assume a little journalistic license when he wrote:

In July of 1914, the British and German ambassadors lived in houses facing each other across Connecticut Avenue, the bathroom of one looking...into the bathroom of the other. In the mornings...each looked...at the other and smiled...—old colleagues beginning the day with ivory-handled straight razors and badger shaving brushes...A month later, their countries were at war.

Other Uses of Ivory

95 Of all the items that are associated with ivory, none evokes as much conversation as pistols. George C. Scott, playing General George Patton in the monumental film, *Patton,* scorns the reporter who at one point asks about the non-regulation "pearl-handled pistols" he wears. "Mother-of-pearl is for sissies," Patton growls, in an epic non-answer to an irrelevant question. "They're ivory," he proudly proclaims. The implication, of course, is that ivory— the living tooth of the world's largest animal—is the trophy of a real man brave enough and good enough to be able to obtain it from its original owner. It is for this reason also that ivory figures so prominently in swords, daggers, knives, and other forms of weaponry.

Collecting Ivory Today

101 See James Clavell's *Tai Pan* (William Morrow & Co.) for a marvelous discription of an Englishman's life in 19th century China. See also George C. Williamson, *The Book of Ivory,* Frederick Mullex Ltd., 1938, for a discussion of ivory and games.

102 "incessantly of fish..." Quoted in R. C. Bill, *Board and Table Games from Many Civilizations,* 1979 (publisher unknown).

Without doubt, the most impressive book on chess pieces is Victor Keats, *The Illustrated Guide to World Chess Sets,* St. Martin's Press, 1985. The book shows an ivory and silver set made in the shape of miniature shofarim (the ram's horn blown to herald the Jewish New Year). Such an 18th century treasure was on sale at Donohoe's in Davies Mews, London, for £9,500 (about $15,000) in 1987.

103 On washing ivories, see note above at page 17.

104 "...for my vesture..." John 19:24.

105 Among rare collections today touching on ivory is Jeffrey Davidson's 75 pairs of *chopsticks.* "Very esoteric...quite unusual" according to Sotheby's. Ralph and Terry Kovel of Beachwood, Ohio, write extensively and interestingly on antiques and collectibles. Any of their publications is worthy of review. But of all things collected, perhaps the 472 different pairs of *socks* (Army green, bobby, early panty hose, Mickey Mouse, etc.) recently donated to the North Carolina State University textile museum is the most unusual. (*The Wall St. Journal,* March 5, 1987). It also makes the point of the importance of collecting everyday items for the benefit of the understanding of future generations.

106 In 1988, the first 141 of a promised gift of some 600 netsuke arrived at the Los Angeles County Museum of Art—part of the Raymond and Frances Bushnell collection. Bushnell said he gave about half of his high quality netsuke pieces to Los Angeles because its museum "has a strong interest in Oriental art [and] it has primary material, such as paintings, but not the minor arts, so I know they will make good use of the netsuke" (*Los Angeles Times,* January 30, 1988). The story about enticing Mr. Bushnell into a meeting was described by Scott Meredith, *Parade,* March 4, 1986.

"So much of the past..." Lillian Baker, *Hatpins and Hatpin Holders,* p. 9. Tony Hyman, who collects information on who collects what, estimates that only 7 percent of the American population is into serious collecting. But that still amounts to some 17.5 million people.

107 "Since Anglo..." *Encyclopedia of Antiques, p. 310.*

110 For a comprehensive understanding of the plight of the elephant in Africa and a highly informed look at how government policy sometimes panders to emotional conservationism, see Ian Parker and Mohamed Amin, *Ivory Crisis,* Ghatto & Windus, Ltd., 1983. It is a difficult issue. The World Wildlife Fund, for example, recognizes that the demand for ivory is only one of several causes for the reduction in elephant herds in Africa. Its tiny 1985 pamphlet on elephants, attached to a stuffed animal made by Determined Productions of San Francisco, is noteworthy because of its comprehensive detail. Yet in magazine ads in 1989—

under a headline: "YOU HAVE TO KILL A WHOLE ELEPHANT TO GET A LITTLE IVORY"—the organization ignored its previously well-balanced approach when it told readers: "Don't buy ivory, new or old." We disagree with absolutists. There is also the human side of the ivory trade that is often ignored, but must be addressed. The Associated Press reported on October 31, 1989, that some 30,000 people in Japan and 4,000 in Hong Kong are directly involved in the ivory trade and will likely lose their source of livelihood.

112 The majesty of governments acting collectively and the force of an international treaty fairly resounds in the formal U.S. Presidential proclamation issued on CITES:

CONSIDERING THAT:

The Convention on International Trade in Endangered Species of Wild Fauna and Flora was open for signature at Washington from March 3, 1973 to April 30, 1973, and thereafter at Bern until December 31, 1974, and was signed on behalf of the United States of America on March 3, 1973, a certified copy of which Convention in the Chinese, English, French, Russian, and Spanish languages in hereto annexed;

The Senate of the United States of America by its resolution of August 3, 1973, two-thirds of the Senators present concurring therein, gave its advice and consent to ratification of the Convention;

The President of the United States of America, on September 13, 1973, ratified the Convention...and the United States of America deposited its instrument of ratification with the Government of the Swiss Confederation on January 14, 1974;

NOW THEREFORE, I, Gerald R. Ford, President of the United States of America, proclaim and make public the Convention, to the end that it shall be observed and fulfilled with good faith on and after July 1, 1975, by the United States of America and by the citizens of the United States of America and all other persons subject to the jurisdiction thereof.

IN WITNESS WHEREOF, I have signed this proclamation and caused the Seal of the United States of America to be affixed.

DONE at the city of Washington this twelfth day of May in the year of our Lord one thousand nine hundred seventy-five and of the Independence of the United States of America the one hundred ninety-ninth.

GERALD R. FORD

By the President:
[SEAL] HENRY A. KISSINGER
Secretary of State

116 Mrs. Julia Harland, the Assistant to the Surveyor of the Queen's Works of Art in the Lord Chamberlain's Office at St. James's Palace, wrote to the author on January 27, 1987, that "none of the [first] set of Telephones...made expressly for Her Majesty's use survives today." Queen Victoria described her initial telephone conversation, under the personal supervision of Professor Alexander Graham Bell, as "most extraordinary" and later asked if she could purchase the instruments she had used. Bell responded in 1878 that they were "commercial" instruments and that "it will give me much pleasure to be permitted to offer...a set of telephones to be made expressly for Her Majesty's use." It is that set that was said to have been made with ivory. One final ironic note: Thomas B. Constain writes in *The Chord of Steel: The Story of the Invention of the Telephone*, Doubleday, 1960, that Bell's *mother* met his father when she "was painting a miniature portrait [of him] on ivory." (p. 25.)

For a comprehensive discussion of Bakelite, see Sylvia Katz, *Plastics: Designs and Materials*, Cassel and Collier.

INDEX

127

2871

ABOUT THE AUTHOR AND HIS IVORY COLLECTION

Photo by José A. Dollander L.

GODFREY HARRIS has been collecting objects made from or with ivory since 1948 when he accompanied his father to England on an antique buying trip. That experience not only began a lifelong quest for unusual pieces, but it impelled him toward a career in international affairs.

Harris has been President and chief executive officer of Harris/Ragan Management Group, an international public policy consulting firm—with offices in Los Angeles, Washington, London, and Panama—for the past 23 years. When travelling on assignment for clients, he is constantly on the lookout for older items to improve his personal collection and build on his knowledge of how and why ivory was used as a decorative and practical material.

Prior to founding Harris/Ragan in 1968, Harris was Special Assistant to the President of the IOS Development Company where he served as a private diplomat for the company. Before joining the Geneva-based firm, Harris was a Foreign Service Officer in the Department of State, with management and diplomatic assignments in Washington, Bonn, and London, and as a Management Analyst in the President's Executive Office, with staff responsibility for management and organizational matters within the foreign affairs and commercial sectors of the Federal government.

In addition, Harris has taught political science at UCLA and Rutgers University, written or co-authored some 11 books (including *The Quest for Foreign Affairs Officers, Commercial Translations, Promoting International Tourism, From Trash to Treasure, The Ultimate Black Book, Panama's Position, The Panamanian Perspective,* and *Invasion*). Harris holds degrees from Stanford University and the University of California, Los Angeles.

His personal collection, consisting of some 600 individual objects made from or with ivory, is considered one of the more comprehensive private collections in the United States.